THE
LIFE & WORK
OF
HENRY SCOTT TUKE

1858 - 1929

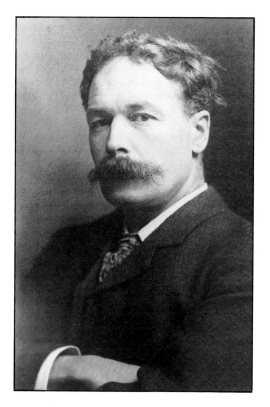

A MONOGRAPH BY

EMMANUEL COOPER

Éditions Aubrey Walter
England

THE
LIFE & WORK
OF

HENRY SCOTT TUKE

1858 - 1929

First published 1987 by GMP Publishers Ltd
Second impression published 1988
Paperback edition first published 1997 by Éditions Aubrey Walter
Heretic Books Ltd., P O Box 247, Swaffham, Norfolk PE37 8PA, England
Fax +44 1366 328 102 Phone +44 1366 328 101
e-mail aubrey@gmppubs.co.uk web-site http://www.gmppubs.co.uk

Distributed in Europe by
Central Books Ltd
99 Wallis Road, London, E9 5LN
Fax +44 181 533 5821 Phone +44 181 986 4854

Distributed in North America by
LPC/InBook
1436 West Randolph Street, Chicago, IL 60607, U S A
Fax +1 312 432 7601 Phone +1 312 432 7650

Distributed in Australia & New Zealand by:
Bulldog Books
P O Box 300, Beaconsfield, NSW 2014, Australia
Fax +61 2 9699 3527 Phone +61 2 9699 3507

Designed and packaged in EU
Printed in Hong Kong

Henry Scott Tuke 1858 - 1929

Henry Scott Tuke's epithet 'Painter of Youth' is well deserved. His largest and most important paintings are of nude youthful males shown in natural surroundings, usually by the sea, swimming, diving, lounging or lying, under a sky of Mediterranean blue. Tuke worked outside the mainstream of art, with both his subject matter and his fresh use of paint, pursuing his particular ideas with enthusiasm and an unswerving determination (as he himself said) 'to paint the nude in the open air'. [1]

Born the second child of staunch but liberal minded Quaker parents in York in 1858, Henry Scott Tuke had shown particular aptitude as a child for art. His drawings of ships were competent and he filled his letters with illustrations and sketches. The family background was in the medical profession: his great-great-grandfather had founded the Friends' Retreat in York in 1792 for the humane care of the mentally ill, and his father Doctor Hack Tuke was a specialist in the treatment of mental disease. Tuke's childhood and youth was spent in Falmouth, Cornwall, where the family moved in 1861 for the benefit of Dr Tuke's health; Maria, his sister, who later wrote his biography[2] was born here. In Falmouth Tuke learnt to swim and he greatly enjoyed exploring the unspoilt countryside and remote beaches. With his brother he attended the Quaker school in Weston-super-Mare.

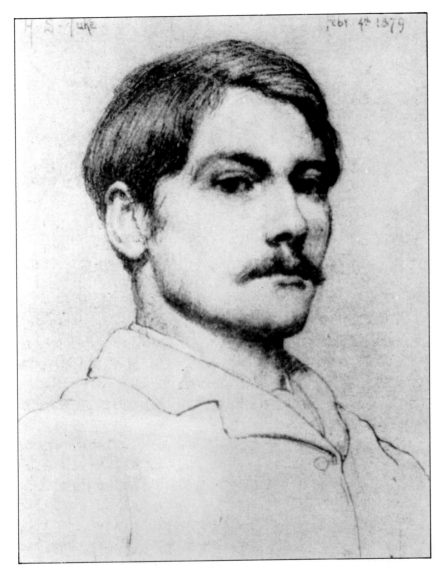

Self-portrait 1879
etching
Illustrated in Maria Tuke Sainsbury's memoir.

In 1874 the family moved to London, settling in Bloomsbury, to provide a home while Tuke's brother studied medicine at University College. There was a suggestion that Tuke should work in a bank, but his talents and preferences lay in the direction of art and, after much discussion, it was agreed that he could enrol at the Slade School of Art. To devout Quakers the visual arts had little place in their lives, save of subjects relevant to their faith. Lydia Tregelles, a devout and old Quaker, asked Tuke in the late 1870s 'Does thy father quite concur in thy profession?' Tuke had no doubt about his chosen career, and at the Slade (1875-79) proved to be an able and willing scholar, winning a three year Slade Scholarship in 1877.

Though adopting many progressive ideas (including teaching female students) the Slade offered a highly academic formal training. E.J.Poynter was Professor and great emphasis was put on drawing. For the first year students drew from plaster casts of classical statues – 'The Antique Class' – with occasional advice from the Professor. Compositions had to be carefully worked out in the studio and there was little instruction in handling paint. Etching was taught by Alphonse Legros (1837-1911) very much in the tradition of Ingres. Tuke handled this technique with confidence and skill though he never returned to it. The idea of the 'well made' picture was one which remained with Tuke, even though he evolved a completely different handling of paint with little regard to what contemporary artists called 'finish'.

From London Tuke travelled to Europe to study and make copies of the great Italian masters and to attend one of the French ateliers in Paris. In Florence Tuke dutifully copied the works of Titian, Bronzino and Correggio, but it was the meeting with the *plein air* English painter Arthur Lemon (1850-1912) which was to have the greatest effect on his work.

Following the ideas of the Impressionists, Lemon encouraged him to consider the events of everyday life as suitable subjects and to paint by close observation rather than in any classical or romantic mode. This move towards naturalism was clearly to Tuke's liking. The two artists spent a few weeks at Pietra Santa, a coastal village some sixty miles from Florence, painting on the beach. 'We have done several nude boys on the beach which is more useful to me than anything. They sit till they are incapable of sitting any longer and are richly rewarded with 2d[two pence]', wrote Tuke in his diary.

In Paris (1881-83) Tuke enrolled at the studio of the highly respected French historical painter and teacher Jean Paul Laurens. Here he worked with students from many other countries as well as England. Unlike the formal, academic teaching at the Slade, Laurens paid particular attention to individual needs. Tuke met many writers and artists who included Oscar Wilde, John Singer Sargent and Jules Bastien Lepage. Impressed with Leparge's *plein air* painting, Tuke visited him in his studio and later showed him a selection of his own sketches. Tuke also became intrigued with the experiments of Alexander Harrison (3) in placing nude subjects in rural settings and orchards. These, Tuke said, 'seemed to open up fresh vistas, and certainly gave new interest to the study of the undraped figure, to depict it with the pure daylight upon it, instead of the artificial lighting of the studio'. Tuke preferred 'working in the open to the close air of a room, especially at the temperature which is necessary to maintain when you are working from the life'.(4)

Girl with Pitcher 1884
oil on panel (34 x 20)cms
David Messum Gallery, Beaconsfield.
Thought to be a study of Lizzie Ann Harvey,
painted in Penzance during the summer of
1884.

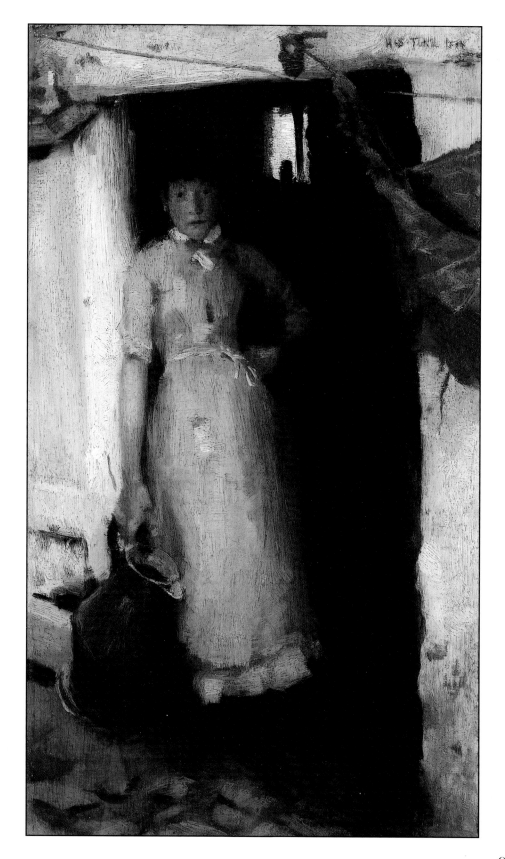

Back in England Tuke was ready to set up his own studio. In 1883 he visited the fishing village of Newlyn in Cornwall where a group of ten or so artists, most of whom had been his co-students at the Slade or in Paris, were involved in setting up a *plein air* school of painting. Inspired by the work and ideas of Lepage, they wanted to depict scenes of daily life, painting out of doors in a naturalist style. Tuke was a founder member of the Newlyn School and worked for some time in the town. 'Dinner Time' (*below*), a study of local youth Ambrose Ruffignac, in the sail loft eating his pasty, was painted in Newlyn. More typical of the Newlyn 'broadbrush' technique is 'Girl with Pitcher' (*p.9*) painted in 1884 in the town. Later Tuke developed a freer use of paint more in keeping with his outdoor models.

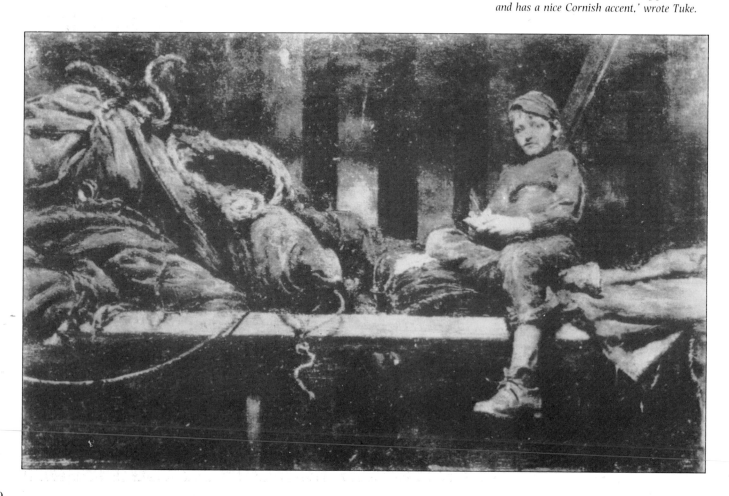

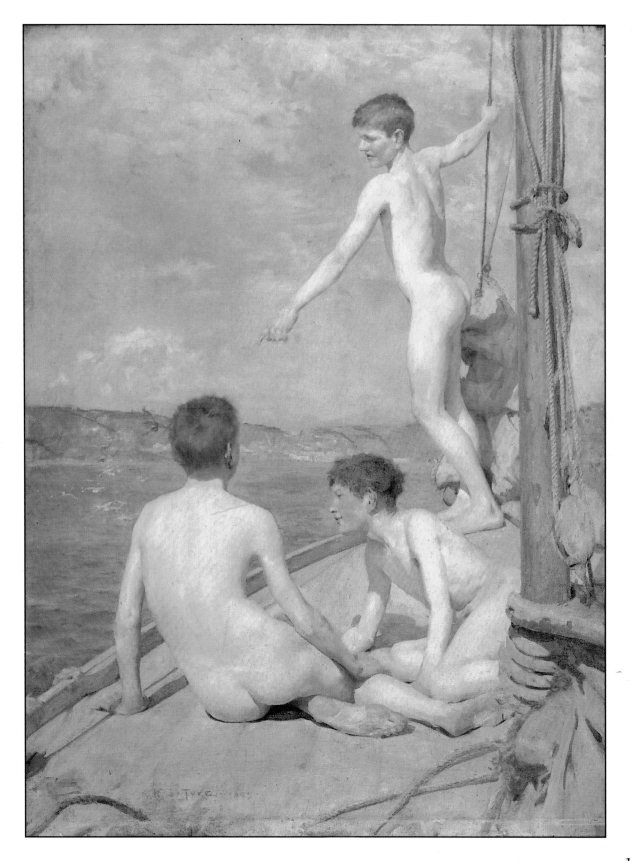

In 1885 Tuke moved to Falmouth, some forty miles from Newlyn, finding two rooms in Pennance Cottage at Swanpool on the southern edge of the town. This was the house he was to occupy until his death 45 years later. Falmouth proved to be an ideal base. He was near to, but not part of, the Newlyn artistic community; he could travel to London where he had a wide circle of friends and where he obtained portrait commissions for which he was paid high fees. His parents and his sister lived in London and they provided a studio where he could work. Pennance Cottage was on the edge of the cliff and from here Tuke had an excellent view across Falmouth Bay. On the more remote deserted beaches he could paint undisturbed. The harbour provided the opportunity for him to practise his skills as a first class sailor, and to moor his own craft. He acquired the 'Julie of Nantes', an old unseaworthy French brigantine and moored this off Green Bank in the harbour. The 'Julie' was converted into a floating studio and living quarters where he could pose his models and entertain friends in privacy. Tuke took with him to Falmouth Walter Shilling, a regular life model at the Slade School of Art, whom he could pose for his work. In 'Two Falmouth Fisherboys' exhibited as 'Bathers' (*p.11*) in 1886 in the New English Art Club, he used Shilling as the model for both boys. 'I am,' wrote Tuke at the time, 'almost tired of painting the same boy but in the bathing picture I consider him quite impersonal, the vehicle of splendid flesh colour and form.'

During a visit to Newlyn he discussed his work with Stanhope Forbes who wrote to his mother that Tuke 'is staying near Falmouth and likes the place very much, but can get no models and has been forced to have a boy from London whom he boards and lodges. So he is painting this British youth in the style the British matron so strongly objects to'.(5) Soon local youths were encouraged to pose. As Tuke's reputation and respectability became established he rarely lacked for models to whom he paid modest fees. Young men and youths from the working-class shipping town volunteered as models, and many were to remain his friends for years. About Jack Rolling, one of his models, Tuke wrote 'He promises to be a treasure...a quay scamp, a lovable young barbarian who could look like an angel and behave like a demon'.

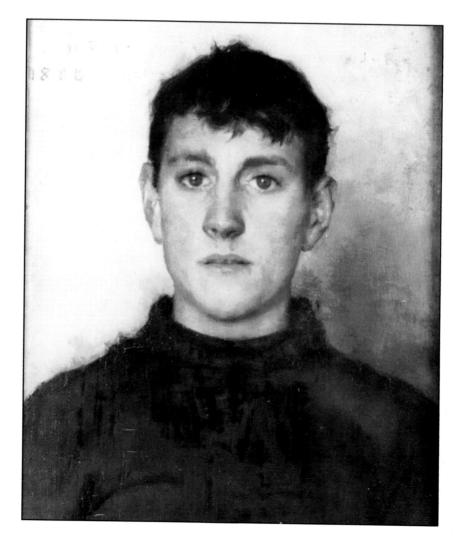

Portrait of Jack Rowling 1888
oil on panel (29 x 23)cms
Tuke Collection, Royal Cornwall Polytechnic Society, Falmouth.
Jack Rowling (Rolling) posed often for the artist.

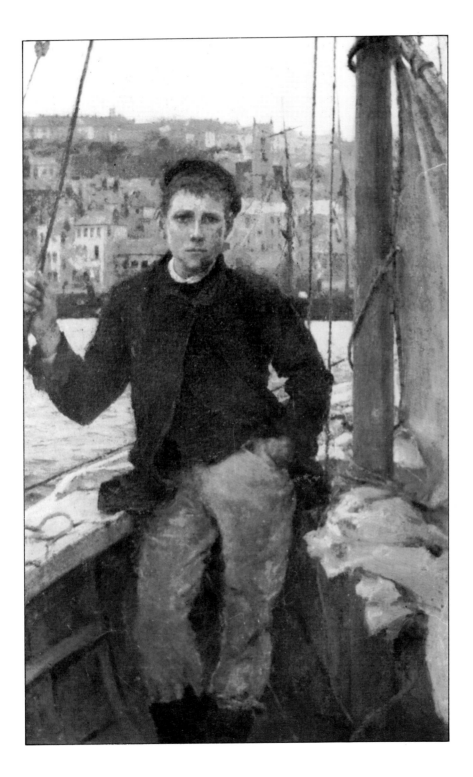

Our Jack 1886
oil on canvas (48 x 31)cms
Tuke Collection, Royal Cornwall
Polytechnic Society, Falmouth.
*Painted on the Lily, the artist's punt, in
Falmouth Harbour.*

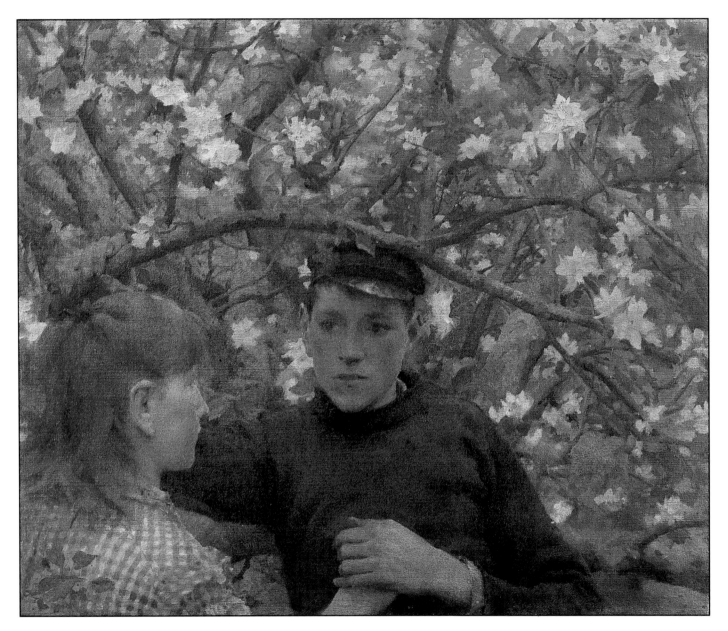

The Promise 1888
oil on canvas (57 x 68)cms
Walker Art Gallery, Liverpool.
Jack Rolling and Jessie Nicholls were the
models who posed in the orchard at Penmere.

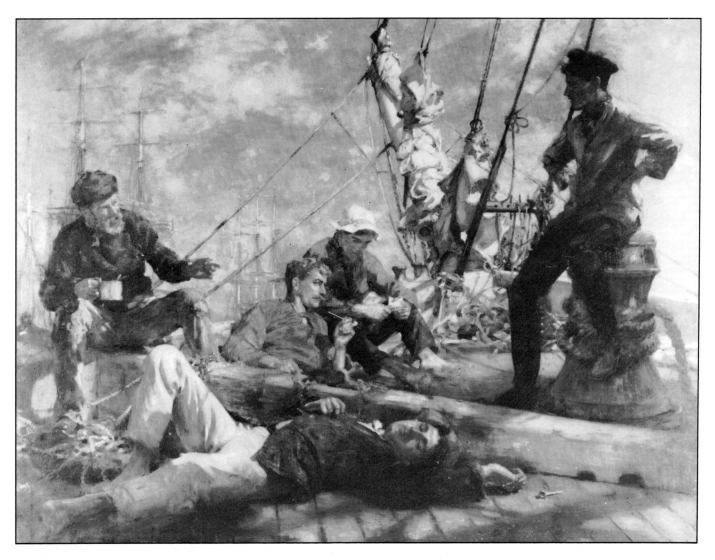

Another model, Johnnie Jackett, who later became cycling champion of Cornwall and a well-known rugby footballer, was described as 'a very intelligent boy who could do anything, either in the studio or the boat'(*above*).

Tuke usually posed his models on board the 'Julie'; at this time his major compositions were narrative and/or anecdotal. For example 'All Hands to the Pumps' (*p.17*), of seven figures aboard a storm-lashed sailing vessel, skilfully wove the sailors into a complex arrangement in which human strength and endurance battled against the elements. Each carefully drawn figure is a study of movement and force with little of the freshness or ease which was to develop later in his more naturalistic paintings of the male nude. The painting has a contrived quality as though the artist had deliberately

The Mid-day Rest (Sailors Yarning) 1906
oil on canvas (101 x 131)cms
Courtesy of Sotheby's, London.
Models included Harry Cleave, Stanley Tiddy, Neddy Hall and Johnny Jackett: painted on board the derelict French barque Mazatlan.

opposite

All Hands to the Pumps! 1888-89
oil on canvas (185 x 140)cms
Tate Gallery, London.
Painted on the deck of the Julie.

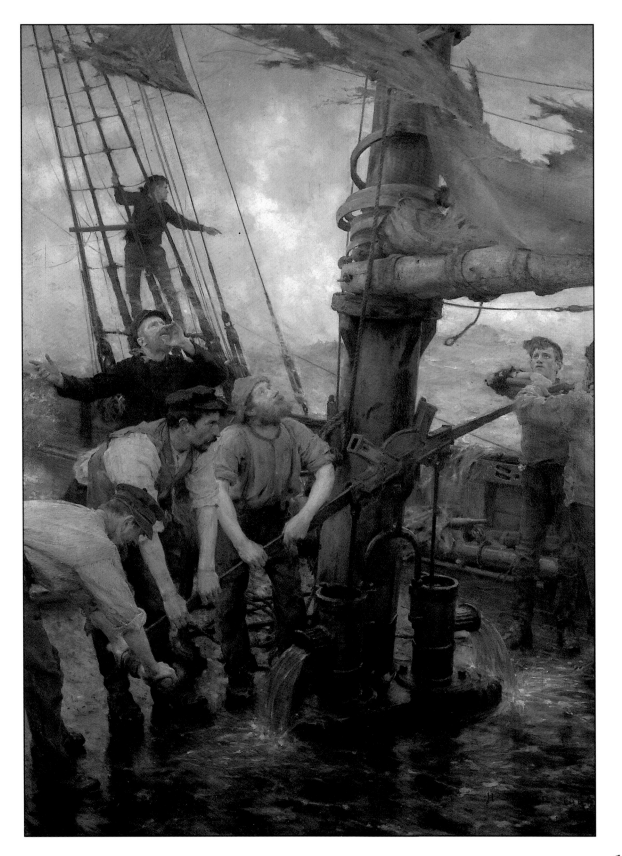

set out to make a composition to demonstrate skill and ingenuity. The formal treatment of figures and handling of form owes much to his sound Slade training. Even if the painting does not totally convey the drama of the occasion, it is a well constructed piece of work. Tuke admitted that this picture was intended to advance his reputation and he was delighted when in 1889 the Chantrey trustees bought it for the nation, paying £420. Other paintings, such as the 'The Run Home' (*p.19*) and 'Try My Soup' (*below*), continue the narrative, anecdotal theme though in a quieter less dramatic form.

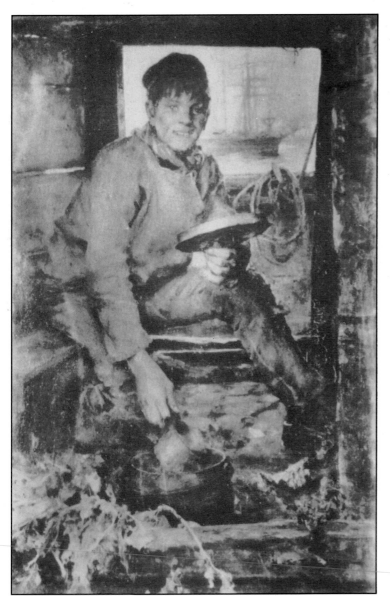

Try My Soup c.1890
oil on canvas (102 x 71)cms
Illustrated in Maria Tuke Sainsbury's memoir.
Painted on board the Julie of Nantes; the model was Billy Hall.

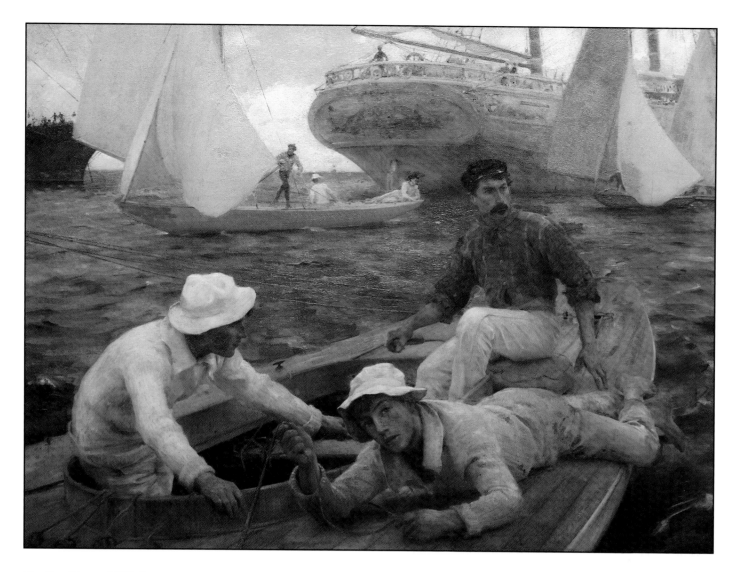

The Run Home 1902-2
oil on canvas (161 x 192)cms
Royal Institute of Cornwall, Truro.
*Set on board the Red Heart, one of Tuke's
racing boats, the main models were Bert
White, Harry Cleave and Sam Hingston.*

For a time Tuke attempted to paint classical themes of subjects taken from literature and mythology. All gave him trouble. 'Hermes At the Pool' was continually being re-painted and when it was shown at the Royal Academy it was poorly received. Tuke later destroyed it. 'Cupid and Sea Nymphs' (*p.21*) was rejected by the Royal Academy in 1899 before Tuke was elected to membership. The painting, exhibited at the New Gallery, has little of the fresh, natural qualities Tuke achieved in his outdoor studies of youths. 'Endymion' (*below*), of a naked youth lying against a tree lost in sleep, was equally unsatisfactory in its attempt to suggest god-like qualities and was never completed: the goddess was never painted in. Tuke's sister, Maria, records in her

Endymion 1893
oil on canvas
The painting was never completed and the artist later destroyed the canvas.

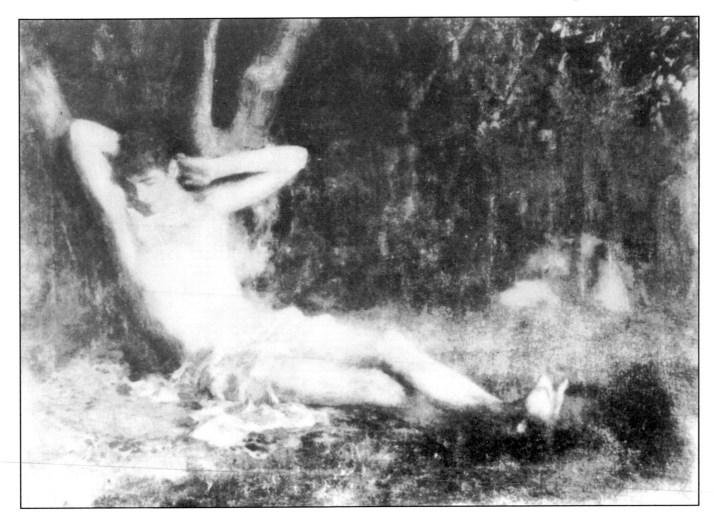

biography of the artist that Endymion's companion Semele was 'the great obstacle'. Most of these paintings remain only in photographic form. The figures often have a stiff, lifeless quality and appear self-conscious and bemused. Tuke was unable to bring them to life in any meaningful way. He seemed not to be particularly interested in the myths and he found the attempt to turn his models into gods (and on occasion goddesses) too problematical. In his diary Tuke commented on his friend, the artist Lindsay Symington noting that 'He does not seem to be so good at painting direct from nature as from impressions received.' Painting direct from nature was Tuke's own gift, wrapping this up in a classical and mythological mantle proved impossible for him.

Cupid and Sea Nymphs 1898-99
oil on canvas
This picture was rejected by the Royal Academy, but did go on show at the New Gallery in 1899.

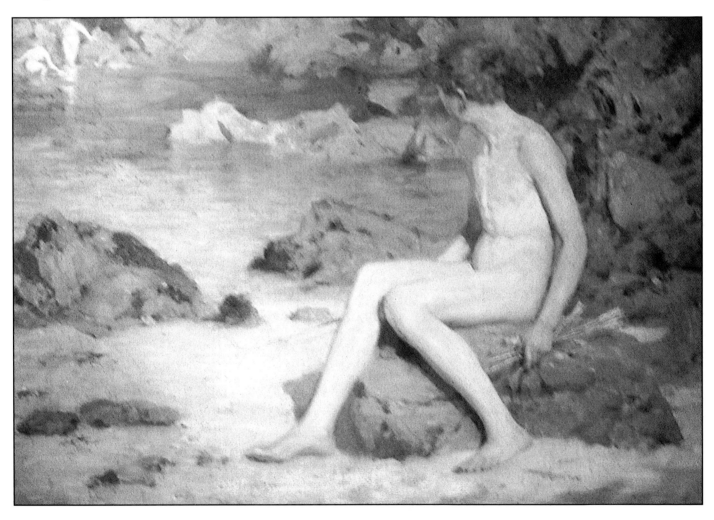

During the 1890s Tuke's style broadened; he felt able to render nude figures without reference to mythological or narrative themes, though some paintings, such as 'The Sunworshipper' (*p.23*) retained some of the 'godlike qualities'. Gradually his handling of paint became freer and his bold and fresh uses of colour had something of the Impressionists' skill. Tuke was encouraged to explore a more naturalist approach by his circle of friends.

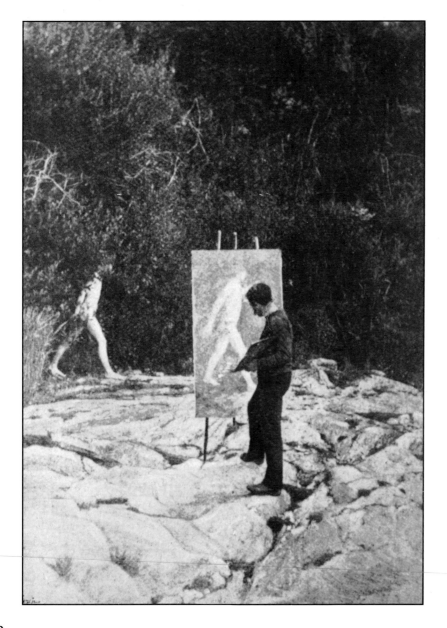

Henry Scott Tuke c.1895
Painting on the beach from nude model.

opposite
The Sunworshipper (To the Morning Sun) 1904
oil on canvas (102 x 79)cms
Hugh Lane Municipal Gallery, Dublin.
Painted in the early morning in Pennace Wood. The model was Georgie Fouracre for the figure and H. E. Allen for the head. 'Put roses in 'Sunworshipper's hair and improved him greatly,' wrote Tuke in his diary.

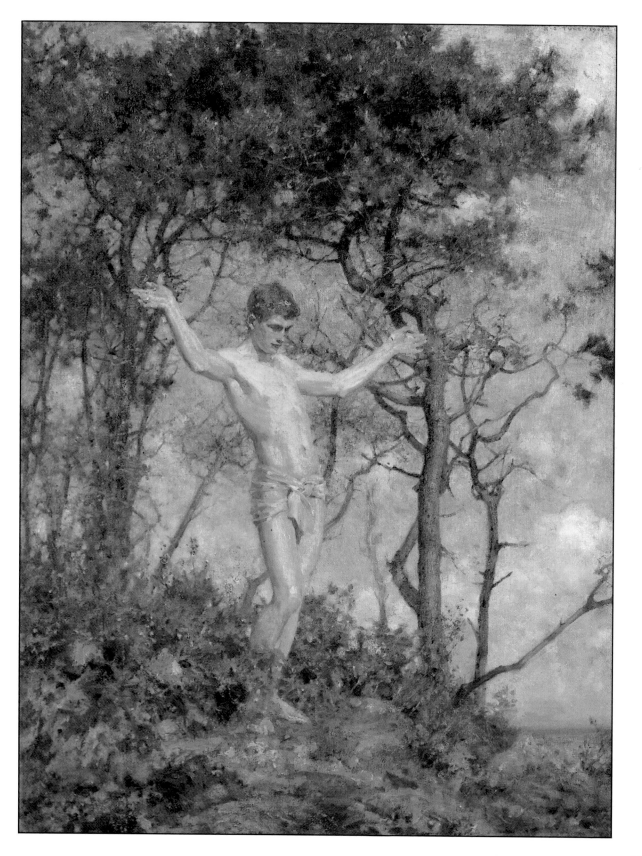

23

A fan letter from John Addington Symonds praising his work mentioned 'Perseus', a painting he had seen in photographic reproduction. 'The feeling for the nude in it seems to me as delicate as it is vigorous.' Later (1893) Symonds, then living in Venice, gave Tuke a sound piece of advice telling him 'You ought to develop studies in the nude without pretending to make them "subject pictures"... your own inspiration is derived from nature's beauty. Classical or Romantic mythologies are not your starting point. Number your pictures Op.1, 2, 3, etc Do not find titles for them. Let them go forth as transcripts from the beauty of the world.'

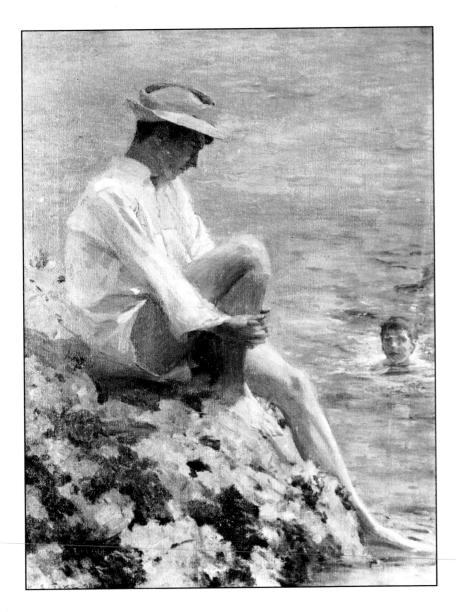

Boys Bathing c.1898
oil on canvas (61 x 46)cms
Museum and Art Gallery, Bristol.

Lord Ronald Gower 1897
oil on canvas (61 x 51)cms
National Portrait Gallery, London.

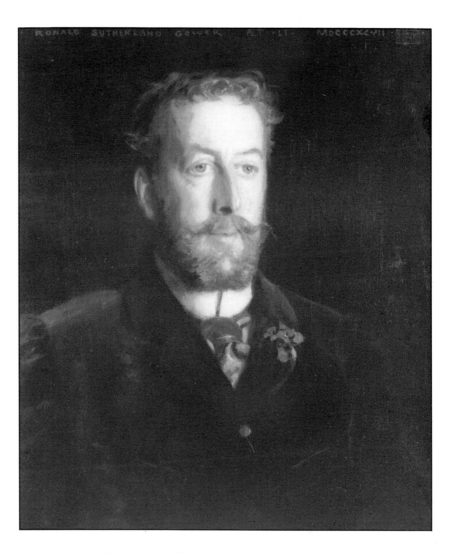

In the late '80s Tuke became part of the Uranian circle of poets and writers where the beauty of male youth was openly written about and discussed.(6) In the first volume of *Studio* (1890) edited by a friend of Tuke's, Joseph William Gleeson White, an illustrated article appeared on 'The Male Nude in Photography'.(7) This included work by Baron Wilhelm von Gloeden, a German count who lived in Taormina, Sicily, of photographs of local youth often in classical Greek poses, and by Frederick Rolfe, the self-styled Baron Corvo. Rolfe was a great admirer of Tuke's work and they met at Gleeson White's home in Christchurch. One of Rolfe's photographs was of Cecil Castle lying naked on his stomach; Castle was the cousin, close friend and possible lover of Charles Kains Jackson, and the two were regular

visitors to Falmouth. Tuke's circle of London friends often met at Gatti's restaurant in Adelaide Street, behind St Martin's, and included Lawrence Housman, George Ives, Horatio Brown, John Gabriel Nicolson and the member of parliament and artist Lord Ronald Gower .(8)

At this time Tuke wrote his own Uranian verse, and his unnamed sonnet was published anonymously in *The Artist*, then edited by Jackson.

Youth, beautiful and daring, and divine,
 Loved of the Gods, when yet the happy earth
 Was joyful in its morning and new birth;
When yet the very odours of the brine
Love's cradle, filled with sweetness all the shrine
 Of Venus, ere these starveling times of dearth,
 Of priest-praised abstinence made void of mirth,
Had given us water where we asked for wine.

Youth, standing sweet, triumphant by the sea
 All freshness of the day and all the light
 Of morn on thy white limbs, firm, bared and bright
For conflict, and assured of victory,
Youth, make one conquest more; and take again
Thy rightful crown, in lovers' hearts to reign!

The poem's description of the beauty of the setting on Newporth Beach, Tuke's favourite painting spot does little to detract from the main theme, that of the god-like beauty of the youthful naked body.

opposite
A Young Boy Standing 1911
oil on canvas mounted on board (43 x 28)cms
Courtesy of Sotheby's, London.

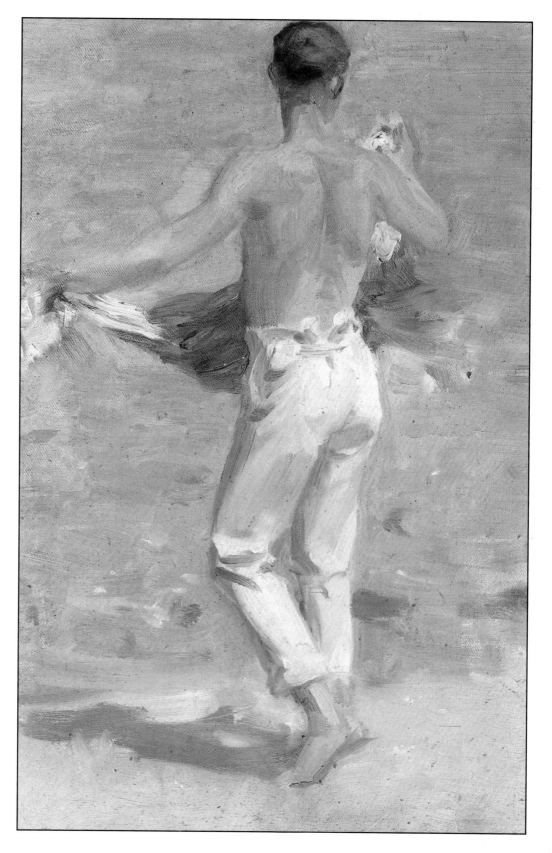

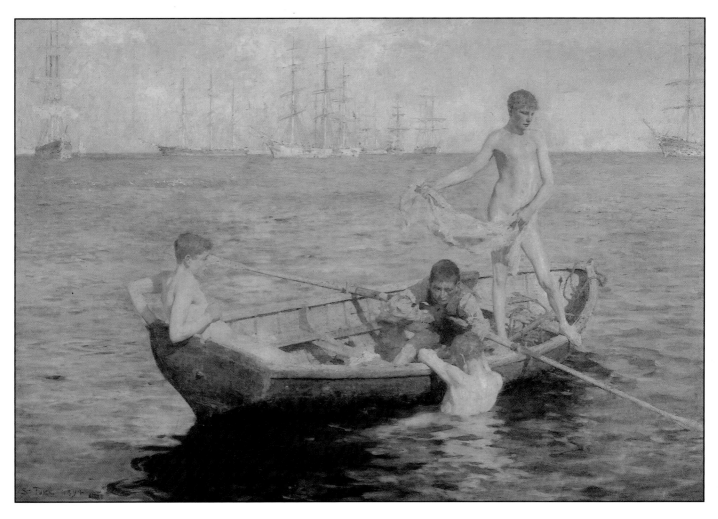

August Blue 1893-94
oil on canvas (122 x 183)cms
Tate Gallery, London.
*Models were Tonkin, Georgy Rolling, Freddy
Hall, Hamley and Ruffy Harris.*

As an artist Tuke had long admired Whistler's 'arrangements' and 'harmonies' and visited him in his studio in Tite Street, Chelsea. Whistler's titles, suggestive of mood and feeling rather than plot or narrative, appealed to Tuke, and he adopted the idea for his studies of youth. 'August Blue' (*p.28*) for example was taken from Swinburne's poem 'The Sundew' but it could equally have been inspired by titles used by his friends, most notably Symonds' essay 'In the Key of Blue'. Other major paintings were given similar titles by Tuke: 'Aquamarine' (*p.65*) and 'Ruby, Gold and Malachite' (*p.33*) for example. 'August Blue', the painting for which Tuke is probably best known, is a dazzling study of nude youths bathing from a boat, bobbing in crystal clear water under bright blue skies. Painted in naturalistic style it is a brilliant portrayal of sunlight on flesh, sea and sky. The mood is one of innocent enjoyment, of healthy young bodies enjoying exercise, sport and play. If it seemed a *risqué* subject for some critics, others found it fresh, alive and sparkling, representing all that was pure and unspoilt, a celebration of the present, a hope for the future. Impressed, the Chantry Trustees paid £525 and bought it for the nation. Tuke's chosen style was given a large measure of official recognition, especially in view of the Trust's earlier purchase of 'All Hands to the Pumps'.

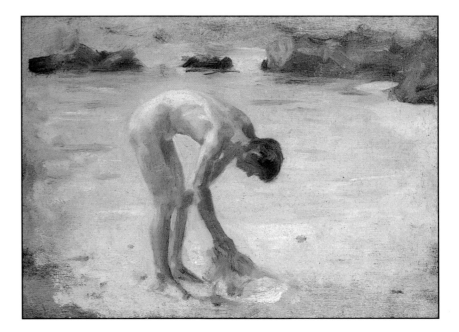

Figure Study for Aquamarine c.1928
oil on board (37 x 28)cms
Pyms Gallery, London.

The Uranian poets saw in Tuke's paintings of working-class youth personification of their own ideals. Horatio Brown, drawing on Tuke's enthusiasm for Falmouth youth, wrote a poem to Johnnie Jackett, one of Tuke's models who first appeared in the artist's Royal Academy oil 'The Swimmers' Pool' (1895). Brown's invitation to Jackett to live with him was certainly refused. Jackett also was the inspiration for other Uranian poets. It was not only Tuke's youthful models which the Uranians found so stimulating but also the activity of bathing. This was a perfect opportunity to observe naked youths without involvement, however much this may have been desired. Aware of the dangers of too close an association with the Uranians Tuke kept a safe distance. Though he entertained his friends in Falmouth, spent time with them in London and abroad (usually at Venice) there is no breath of scandal with regard to his private life.

Three Companions 1905
oil on canvas (61 x 92)cms
Courtesy of Sotheby's, London.
Bert White, Johnny Jackett, Charlie Mitchell and Harry Cleave were the models who posed at different times.

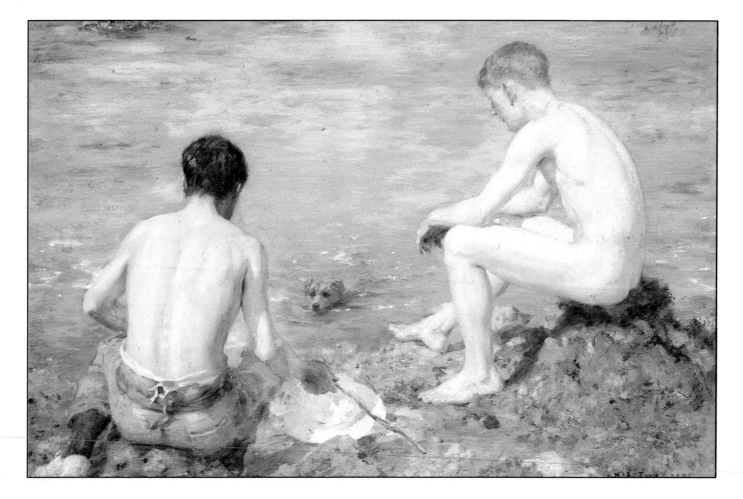

Tuke was clearly greatly attached to his models, showing interest in their lives and activities and maintaining friendships for many years. His paintings steer a middle course. He was well aware of the male form in classical antiquity (9) but he avoided the Greek ideal as exemplified in Frederick Walker's 'The Bathers' (1866-67, *below*) (10) or the sporting feel of W. H. Bartlett's work (*p.32*).(11) Equally he was not attracted by the rather sentimental paintings of young naked children playing on the beach by William Stott of Oldham (*p.32*) or the more sensitive paintings of Edward Stott of boys bathing by a quiet pool. Neither did Tuke identify with the explicit photographs of naked Sicilian youths taken by Baron von Gloeden, though he must have been aware of the suggestive homerotic mood of these pictures and of the interest in them from many of his friends. Artistically, one of Tuke's closest contemporaries was the American painter Thomas Eakins (1844-1916). Eakins' naturalist paintings of naked male youths swimming, or standing in the forest, were inspired partly by a Greek ideal of perfection and by the ideas of comradeship expressed in the poems of Walt Whitman. Eakins got his male students to pose naked while he sketched or photographed them, using the studies for such paintings as 'The Swimming Hole' (1883-85) and 'Arcadia' (c.1883). Occasionally Tuke also took, or persuaded his friends to take, photographs of his nude models. Bert White posed for some of these photographs.

Frederick Walker – **The Bathers** c.1867
oil on canvas (93 x 215)cms
Collection Lady Lever Art Gallery, Port Sunlight, Merseyside.

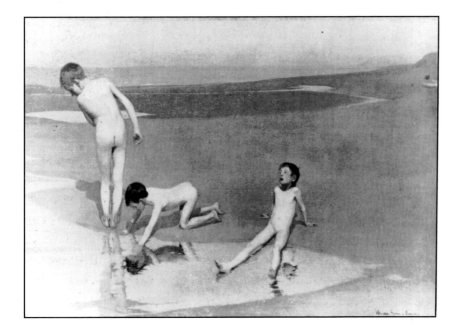

William H. Bartlett – **By the Committee Boat: 'Are You Ready?'**
oil
Shown at the Royal Academy, 1890.

William Stott of Oldham – **Beach Scene**
c.1890
oil on canvas
Illustrated in *The Master Painters of Britain* by Gleeson White.

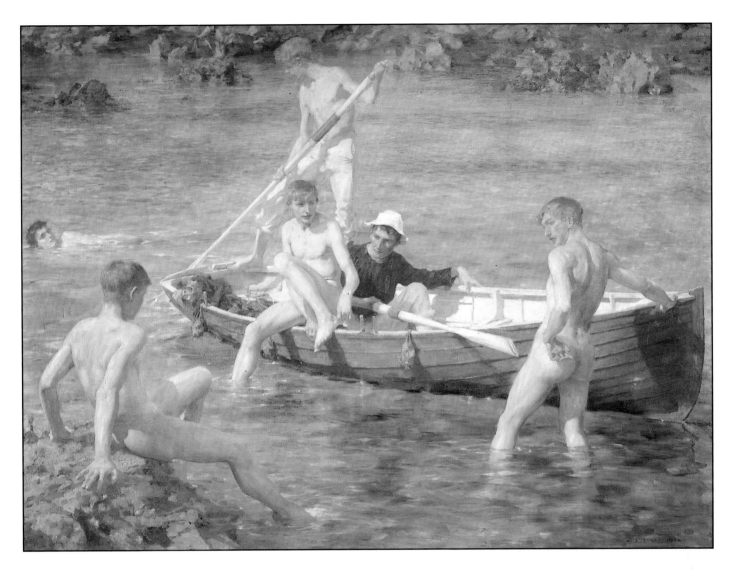

Ruby, Gold and Malachite 1901
oil on canvas (117 x 159)cms
Guildhall Art Gallery, Corporation of
London.
*Painted on Newporth Beach, with Georgie
Fouracre, Charlie Mitchell, Bertie White and
Harry Cleave posing. Mitchell continued to
model regularly for Tuke, and also helped as
studio assistant.*

Tuke's own diaries, largely of day to day events, visits, visitors and so on, give little indication of his own sexual inclination. They contain only one explicit reference to one of his models, Bert White, whom he describes in Greek letters as *kalos*, meaning beautiful but in a particularly sexual way. White, who worked in a local foundry, was a favourite model and Tuke often tempted him to take time off work with requests to pose. A portrait of White, wearing a peaked cap, remained in Tuke's sitting room all his life. White, one of the few models Tuke called by his first name, was one of the figures used for the highly successful 'Ruby, Gold and Malachite' (*above*) painted on Newporth Beach.

Though Tuke's paintings of naked youths suggest a mood of sensual rather than sexual feelings, they are never explicit either in the relationships they describe or in the details of the body. In the oil painting 'Noonday Heat' (*below*) the two youths who relax and rest on the beach are totally engrossed in their private world: neither of them addresses the viewer: their relationship is at once intimate, exclusive and ambiguous. One lies back, the other is more alert, more in command. We can read into the picture both friendship and affection; the homoerotic element is present but not overt. The theme occurs in other paintings. In the watercolour 'Two Boys on a Beach' (*p.35*) there is a freshness which comes from a quick study, again capturing the closeness and intensity of the relationship. The absence of an horizon heightens the feeling of intimacy.

Noonday Heat 1903
oil on canvas (81 x 132)cms
Royal Cornwall Polytechnic Society, Falmouth.
Illustrated in Maria Tuke Sainsbury's memoir.
Models were Georgie Fouracre and Bert White. It was bought by Col. Sydney Lomer in 1922.

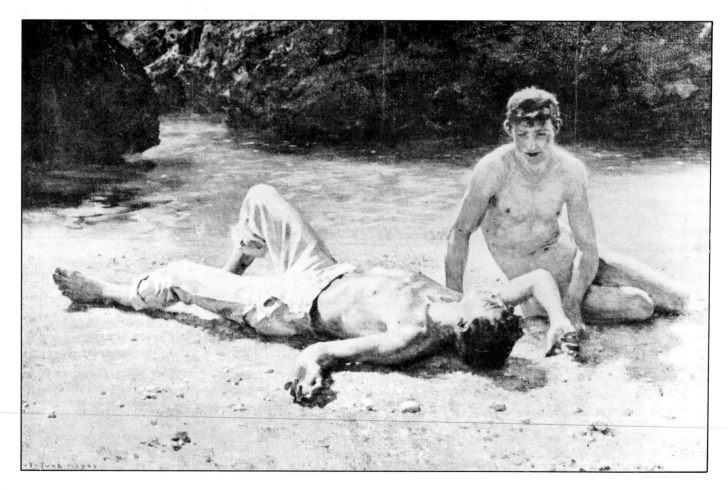

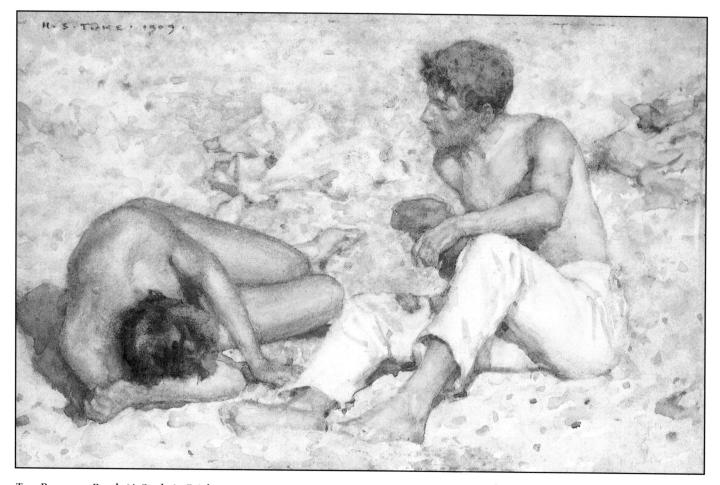

Two Boys on a Beach (A Study in Bright Sunlight) 1909
watercolour (13 x 21)cms
Ashmolean Museum, Oxford.
Presented by C. F. Bell, a keeper at the Museum, who was a lifelong friend of the artist and owned several of Tuke's paintings. It may have been Bell who introduced Tuke's work to T. E. Lawrence who was a schoolboy at Oxford. See p.47 for Tuke's portrait of Lawrence.

Always reluctant to paint in the genital details of his models, Tuke would only do so when pressed. This ensured, at least, that he remained 'respectable' in the eyes of the Falmouth community; it also meant that he could continue to obtain models. More importantly, Tuke wanted to retain in his work an element of idealism. Poses were carefully arranged so that details were concealed. In frontal views shadows were created so that the genitals were obscured. In 'The Diving Place' (*p.36*) a possible buyer (maybe Sidney Lomer) asked for more definition, but when this had been done it was still not purchased. Tuke altered it yet again and the painting remained in his studio until his death. Leonard Duke, a patron of Tuke's, asked for a 'no trouser' version of

'Noonday Heat' (*p.34*) which Tuke painted as a watercolour in 1911 (*p.37*). This version is a much softer, more tender treatment, virtually identical in composition except for the absence of trousers on the model lying on the beach. Significantly the genital details are still sketchy. Similar pictures, for example 'Summer Dreams' (*p.37*) were treated with equal caution. Only in the bronze 'The Watcher' did Tuke model the genitals, and then on a very modest scale.

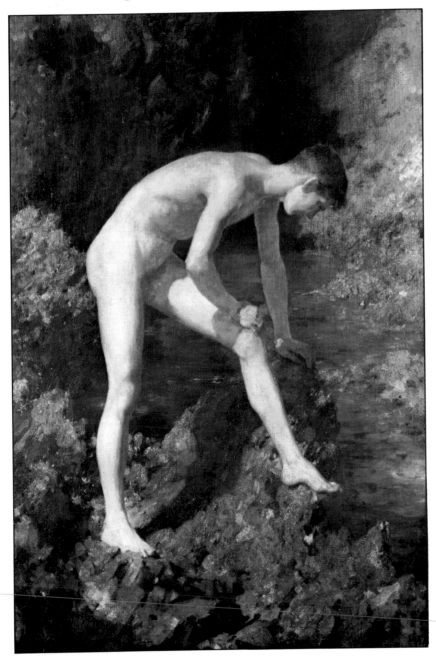

The Diving Place 1907
oil on canvas (132 x 92)cms
Pyms Gallery, London. Now in the Royal Cornwall Polytechnic Society, Falmouth. Illustrated in Maria Tuke Sainsbury's memoir.
The model was Charlie Mitchell who posed on Newporth Beach. A fascinating study for this painting, 'After the Swim' dated 1916, is in the Forbes Magazine Collection, New York.

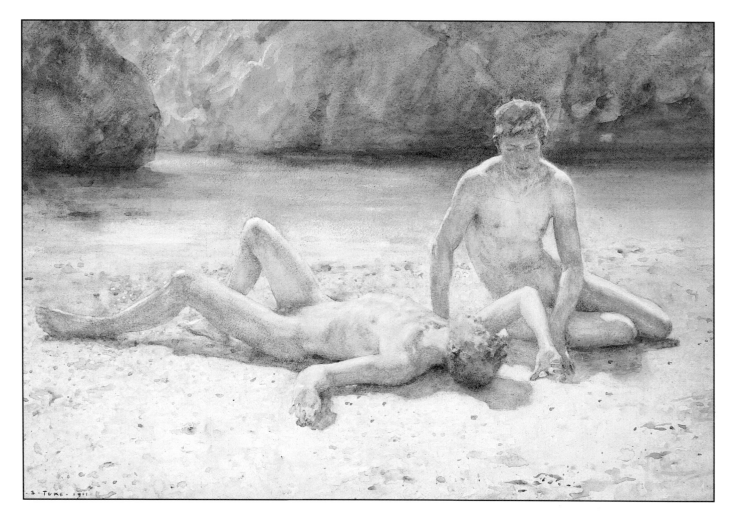

Noonday Heat (Bathing Group) 1911
watercolour (40 x 59.5)cms
Private collection.
This painting, reproduced in The Tatler for 23 August 1933, was a 'no trouser' version of 'Noonday Heat' (p.34).

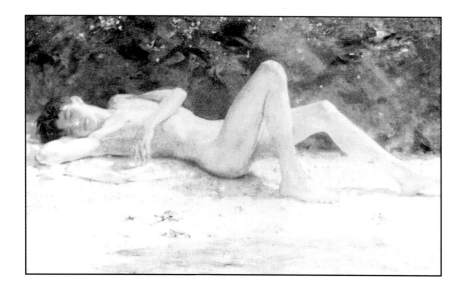

Summer Dreams c.1919
oil on canvas (46 x 81)cms
Reproduced in *Colour*, Vol. II no.5 (Dec. 1919).
The model was Tom White who lay on the gravel at Newporth Beach. In his register Tuke designated this painting as 'One of my best' and did several versions of it.

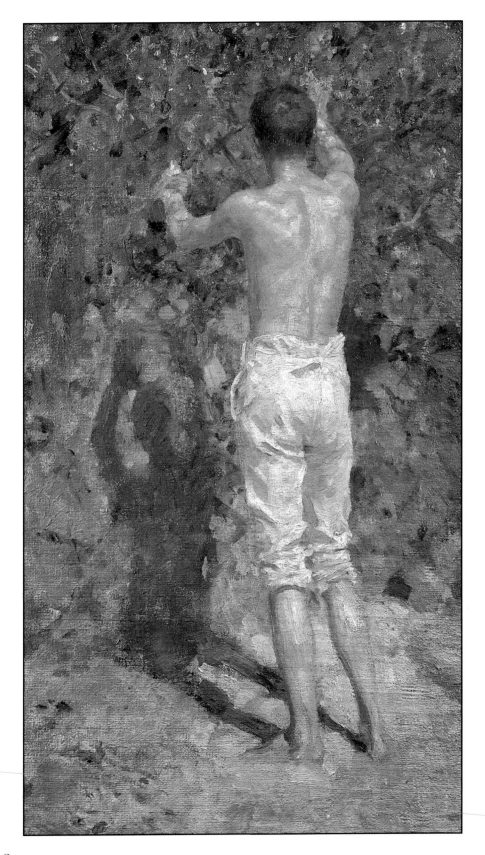

Back of Charlie 1913
oil on canvas board (56 x 32)cms
Pyms Gallery, London.
The model was Charlie Mitchell posed at Newporth Beach against the gorse and blackthorn bushes which extend down the cliffs.

opposite

Bathing Group c.1913
oil on canvas (85 x 60)cms
Royal Academy of Arts, London.
Given by the artist to the Royal Academy when Tuke was elected to full membership. The Italian Nicola Lucciani was the model.

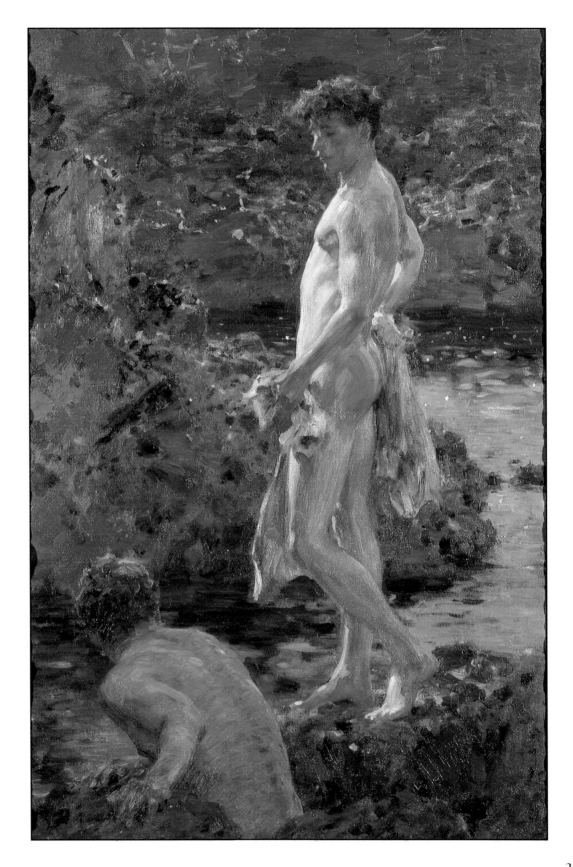

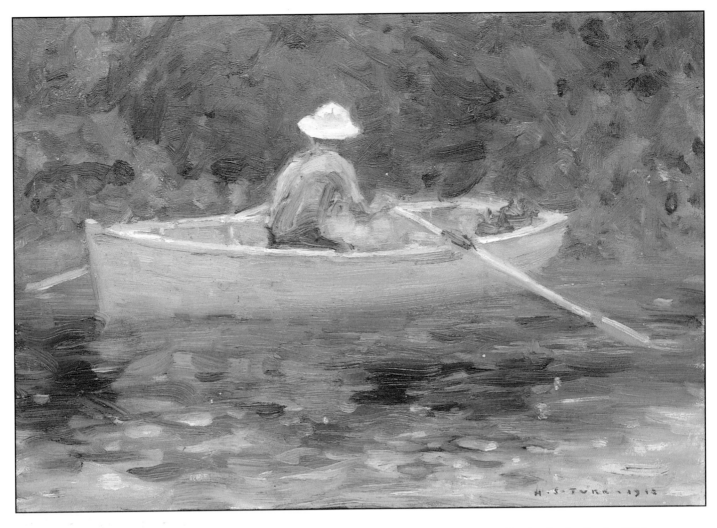

Rowing in the Shade 1913
oil on panel (28 x 38)cms
Courtesy of Sotheby's, London.

Much of Tuke's approach to his subject, whether it was celebrating the beauty of naked youths, capturing the glint of sunlight on water (*p.53*), or the fresh qualities of an orchard (*below*) can be at least partly explained by his complex views on religion. Born and brought up as a Quaker, he had more or less rejected this by his 30s even though he continued to attend meetings, and had developed pacifist and atheist leanings. As a young man Tuke was also a keen Liberal supporter, working actively for the election of a Liberal member of parliament. In 1916 Tuke became a member of the Rationalist Press Association. Many of his ideas were based on the pantheistic belief that god was present in nature, and it was the beauty of nature that he worshipped. This is hinted at in his sonnet in which he attributes divine qualities to youth. To some extent he saw his models as gods, embodiments of physical and spiritual ideals in which the actual details of sex had little part.

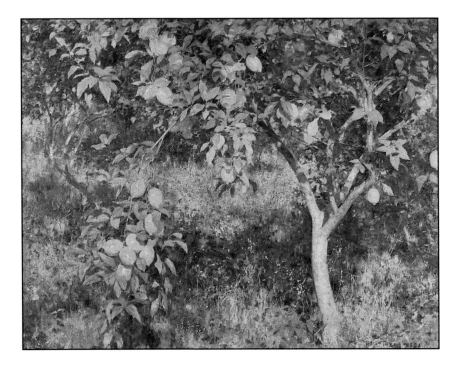

The Lemon Tree 1893
oil on canvas (105 x 136)cms
Cartwright Hall, Bradford.
Originally called 'A Corfu Garden', it was painted in Theotocky's garden at Benitza, Corfu from 6 to 8 in the morning.

In a letter to his father written in August 1879, Tuke demonstrates that he was well aware of the different aspects of his life, and of the need to forge his own path. He wrote, 'I think it is a great mistake to keep work, religion and daily life apart as some people seem to think is necessary to do; they are so dependent on each other that they ought to be moulded together in one simple whole...you have been a most kind and liberal father to us, and it goes against the grain to do things which you disapprove.' This telling letter is a rare statment of 'personal politics' suggesting as it does a considerable measure of self-awareness on the part of the writer.

Henry Scott Tuke 1903
The Tatler for 3 June 1903.
In the garden of Lyndon Lodge, Hanwell, with model. The model was probably Henry Allen who 'came and posed in a holly tree'.

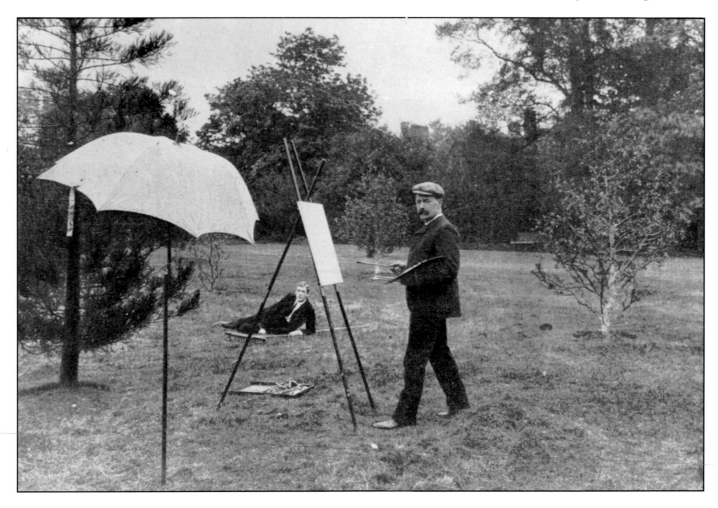

Young Man on the Beach 1909
watercolour (53 x 94)cms
Courtesy of Sotheby's, London.
Possibly a study for one of the figures in 'Two Boys on the Beach' (p.35).

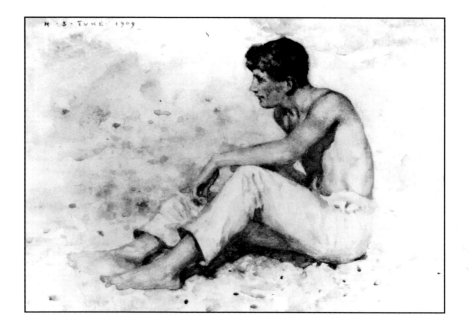

Not all critics liked or welcomed Tuke's favourite subject matter. Some thought he stuck too closely to a 'formula', i.e. one in the boat, two in the water or vice versa, (12) while others would have preferred more 'acceptable' subjects altogether. A critic in the *Cornish Echo* (24.3.1899) commenting on 'The Diver' wrote, 'Mr Tuke seems to find nothing so congenial to his mind as to tackle a subject everybody else would shrink from...Masterly as is Mr Tuke's work, one cannot help feeling regret that he does not give his attention to a more acceptable subject. He is, in the opinion of those competent to judge, the strongest artist outside the Academy circle, and there can be no doubt that had he confined himself to the canons of modern art...he would have been admitted as an Associate of the Royal Academy years ago.'

Undeterred, Tuke continued to paint as he wished, and much to his surprise and delight, he was elected an Associate of the Royal Academy one year later, in 1900. In 1914 he was made a full Royal Academician. Once elected Tuke was able to submit pictures without selection, and regularly put forward his paintings of youths as well as portraits. His skill with watercolour whether with figures or ships (*p.37, p.49*) was recognised when he was elected an Associate of the Royal Watercolour Society in 1904 and a full member in 1911.

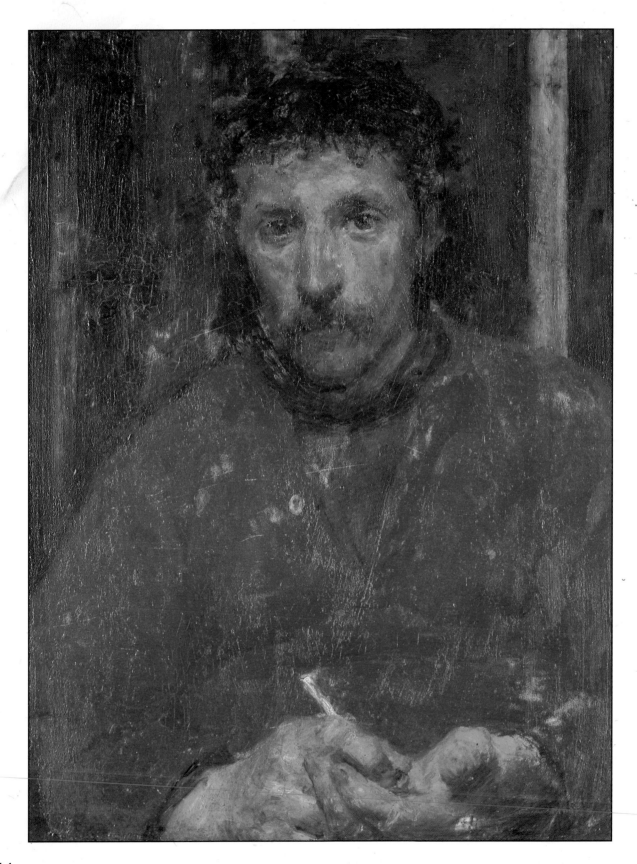

44

Portrait commissions were readily forthcoming, even though Tuke usually asked for about 200 guineas. While he told his friends that he preferred to paint people he knew, he accepted commissions which ranged from formal portraits, which included Lord Gower (*p.25*), a Director of a railway company, the Jam Sahib of Nawanagor, W.G.Grace and Mrs Humphris (*below*) a family acquaintance, to more informal watercolours. Notable among these is Frank Hird (*p.46*), boyfriend of Lord Gower, and the oil of T.E.Lawrence (*p.47*). He also painted the trainees aboard his friend Captain Wheatley Cobb's man-of-war, the 'Foudroyant'.[13] This training ship, moored in Falmouth harbour, was set up to teach working-class youths the skills of sailing, some of whom stayed for many years. Tuke's more casual portraits of his friends and models have a direct charm which is absent in his commissioned work.

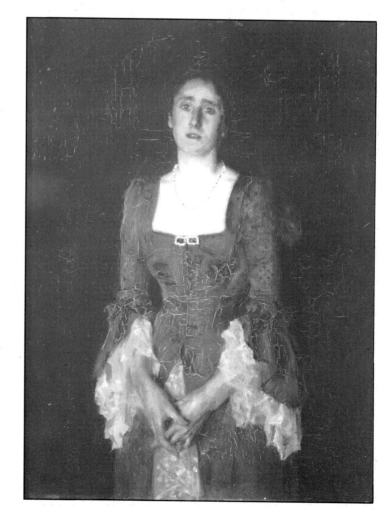

Mrs Florence Humphris 1892
oil on canvas (40 x 32)cms
Tate Gallery, London. Illustrated in Maria Tuke Sainsbury's memoir. *Painted in Falmouth in 1892 and touched up and trimmed in size in 1914, when it was shown at the Royal Academy.*

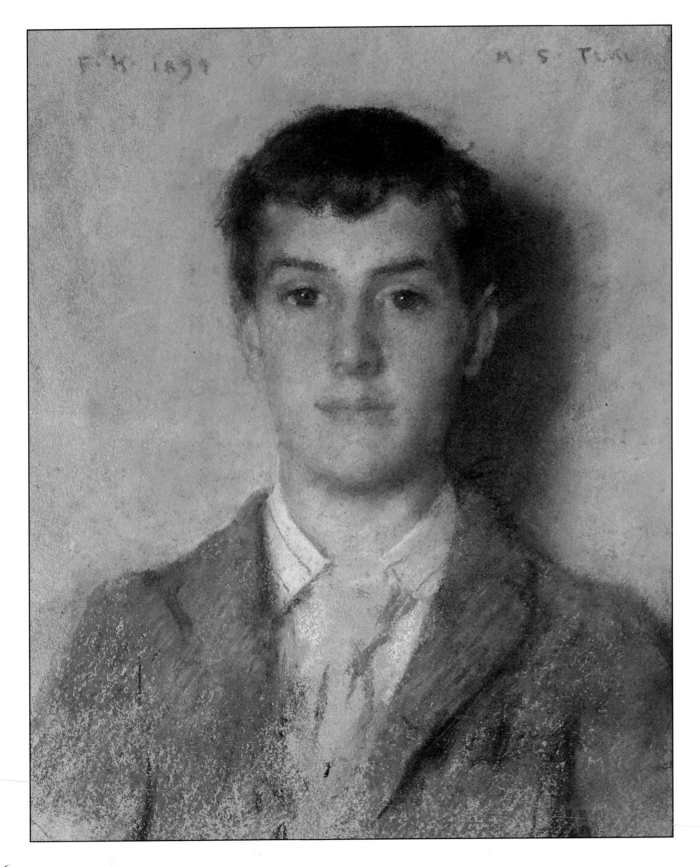

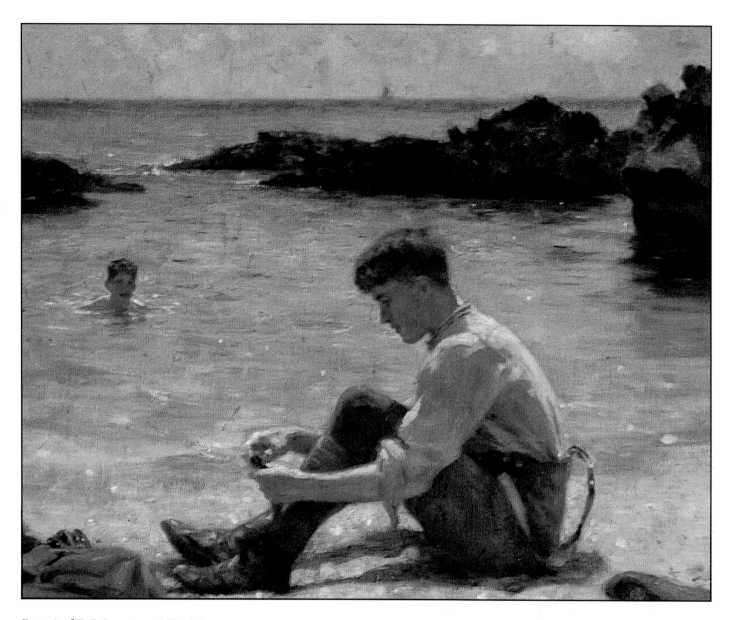

Portrait of T. E. Lawrence 1921-22
watercolour (43 x 53)cms
T. E. Lawrence Museum, Clouds Hill,
Dorset. National Trust.
Originally a sketch for 'Morning Splendour'
(p.67), the figure on the beach of a young
soldier in khaki preparing for a swim was
later altered to that of Lawrence who visited
Falmouth in 1922.

opposite
Portrait of Frank Hird 1894
coloured chalks (29 x 24)cms
Courtesy of Sotheby's, London.
A commission for Lord Ronald Gower.

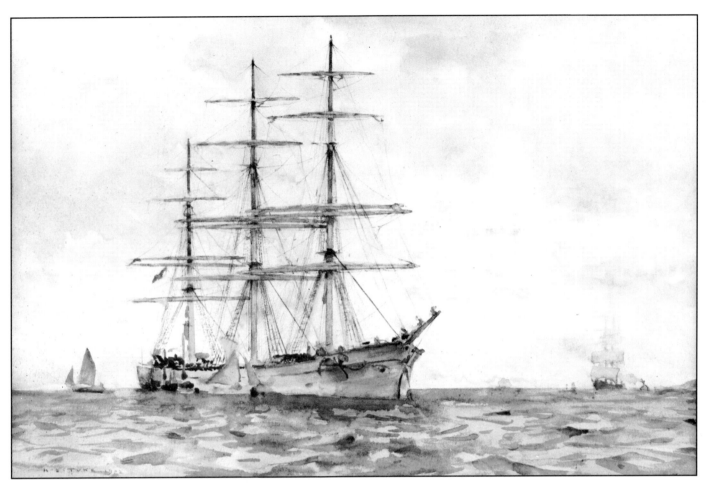

A Fully Rigged Ship 1902
watercolour (31 x 46)cms
Museum and Art Gallery, Bristol.

By 1900 a regular pattern had been established in Tuke's life. Part of the late autumn and winter was spent in London, with Christmas and New Year with his family. His London studio, first at Hanwell and then at Chalk Farm, served as a base for portrait commissions. Visits to Europe were usually made in the spring, either in the company of friends, or to see friends. Falmouth was his home for most of the year. A keen sailor, Tuke raced his yacht and competed in races and sailing events. He was a founder member of the Falmouth Sailing Club and later a member of the Royal Cornwall Yacht Club. Boats and ships fascinated him, and he produced many delicate watercolours of sailing vessels (*above*). These were carefully observed and virtually constitute a survey of sailing ships still afloat. In his diary he noted his sadness when, on travels abroad, he found the sailing ships had disappeared. Many of his ship paintings were sold in the gallery in Falmouth he helped set up.

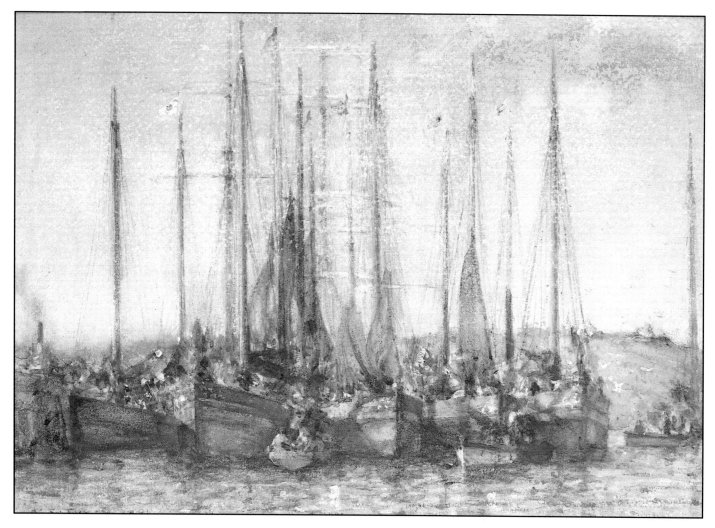

Fishing Boats at Anchor 1901
watercolour (26 x 36)cms
Pyms Gallery, London.

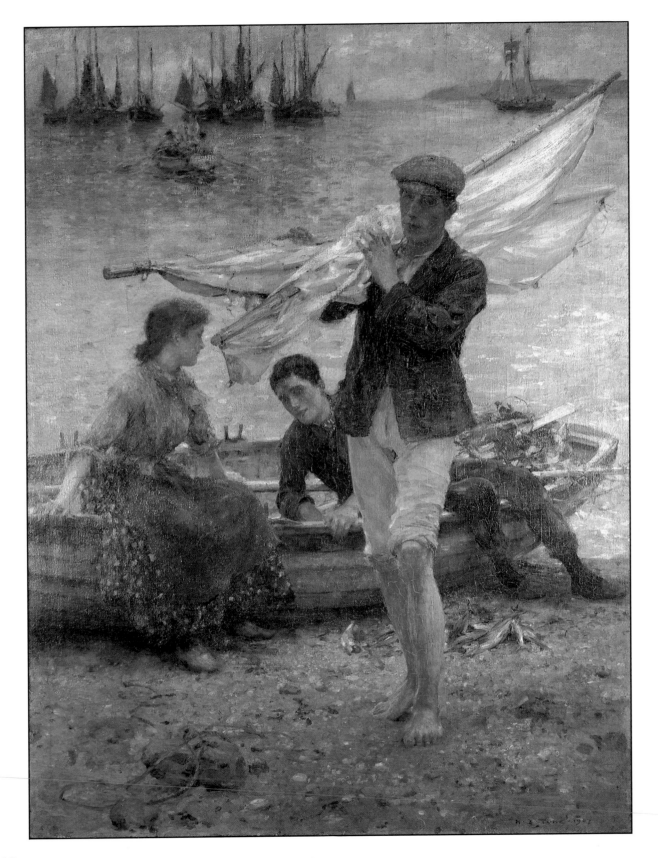

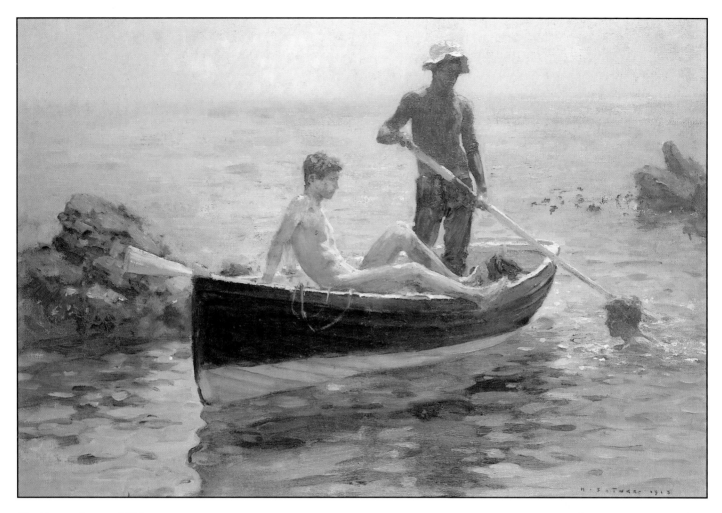

The Orange Jersey 1915
oil on canvas (43 x 64)cms
Pyms Gallery, London.
Charlie Mitchell is the nude model, the
standing figure is Harry Giles.

opposite

Return from Fishing 1907
oil on canvas (111 x 85)cms
Courtesy of Sotheby's, London.

It was, however, the outdoor paintings of youths which
held the greatest fascination for him, and offered the biggest
challenge. The English climate did not deter him, and often
his models became blue with cold. Tuke had admired the
Impressionists (14) but his method of painting was different;
he often employed the classical method of construction with
the triangle as his favourite structure. In various forms this
can be seen in 'Lovers of the Sun' (*p.54*) and 'The Bathers'
(*p.11*). In his use of paint he experimented with a broad
treatment of stroke, particularly in his quick studies. In the

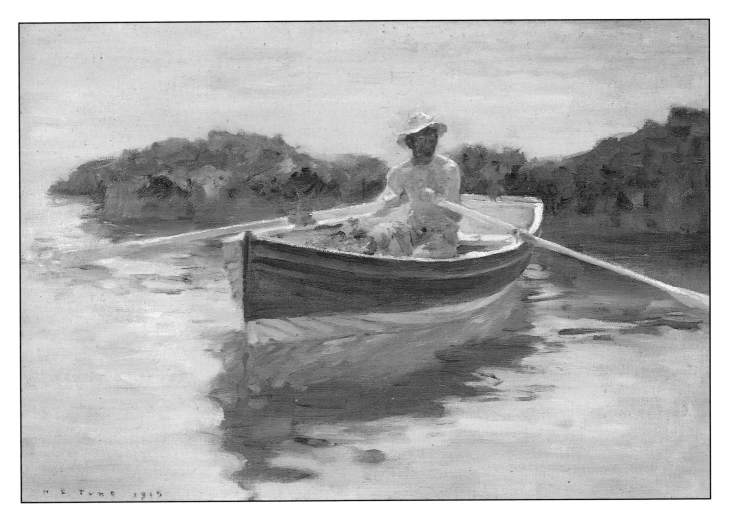

Off the Rocks 1915
oil on board (36 x 53)cms
Courtesy of Sotheby's, London.

sketch 'Youth with Oar' (*p.53*) the treatment of the sea creates a particularly successful shimmering effect, adding to the solidity of the figures. Sometimes Tuke would take his large canvases to the beach to work directly on them. This posed practical difficulties in getting over the cliffs to the remote beach, a problem overcome by taking the equipment in a boat. It was effort well worthwhile, for Tuke maintained 'the truth and beauty of flesh in sunlight by the sea is offered to you in a way impossible to secure in pictures built up from hasty sketches, at leisure, in one's studio.' (15)

opposite

Youth with Oar 1918
oil on board (52 x 34.2)cms
Private collection.

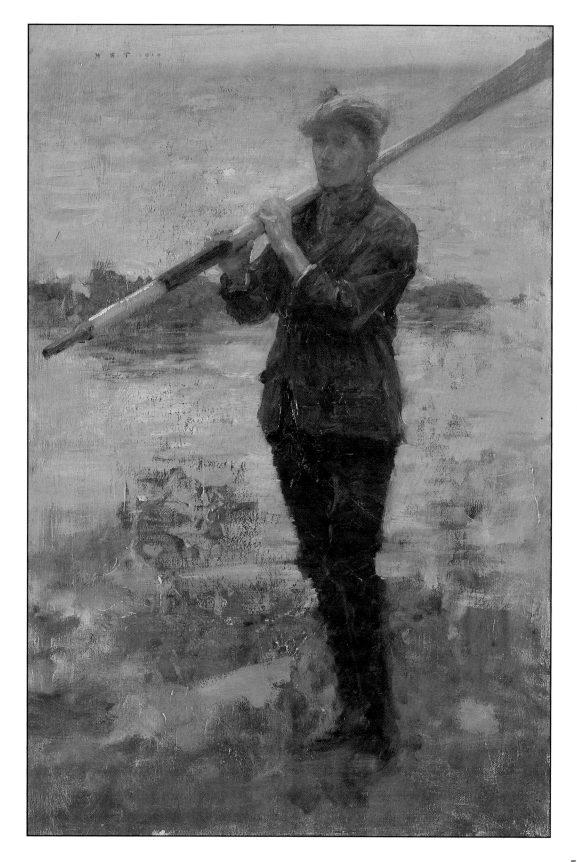

53

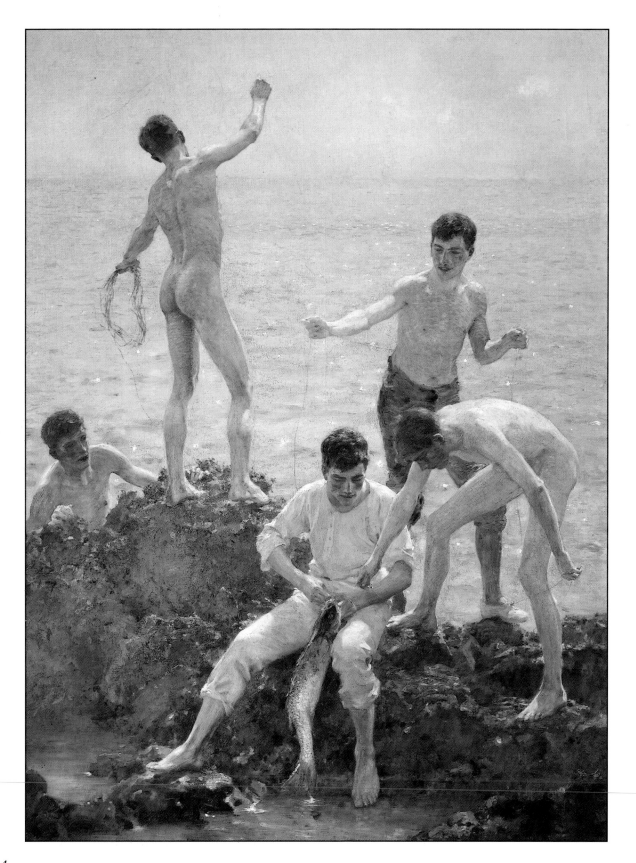

July Sun 1913
oil on canvas (52 x 42)cms
Royal Academy of Arts, London.
The Italian Nicola Lucciani was the model;
the painting was completed virtually in one
sitting. It was given by the artist to the Royal
Academy Schools.

opposite

Lovers of the Sun 1922
oil on canvas (112 x 92)cms
Forbes Magazine Collection, New York.
The chief model was Charlie Mitchell who
worked as Tuke's studio assistant. Donald
Rolph was the model for the head of the figure
on the left. Shown in the British Empire
Exhibition, Wembley, 1924.

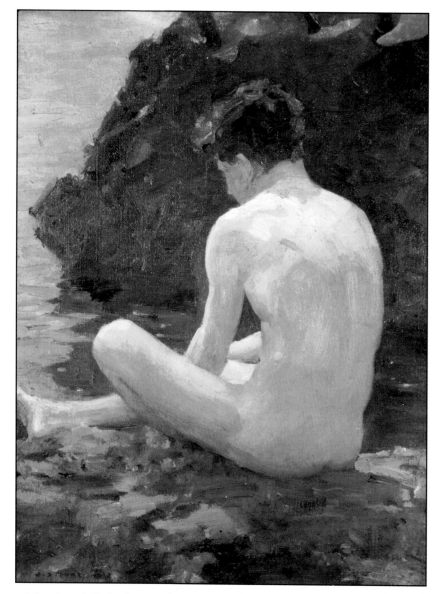

Much of Tuke's work consisted of smaller sized canvases
either with single figures or two figures, in a variety of poses.
These were often sketches for figures which were incorpo-
rated in the larger 'set' pieces, or as experimental treatments
of paint and composition. The oil study 'July Sun' (*above*) of
the Italian model Niccola Lucciani was finished in practically
one sitting. The broad brushstrokes skilfully catch the effects
of light falling on his shoulders. Generally Tuke washed in the
ground using paint thinned with plenty of turpentine. As a
student in Italy he had been taught the theory of green
underpainting (*tutto verde, tutto verde, punto giallo*) but
there is little evidence that he kept up this practice.

Sometimes newspapers were pressed on the surface to help dry out the under paint before the thicker colour was painted in. Tuke did have photographs taken for some poses, but he usually preferred to work direct from the model. Tuke also worked with pastels, using them to obtain particularly rich effects, as in his self portrait (*below*). Watercolours provided a readily portable medium, and these were invariably used for sketching ships.

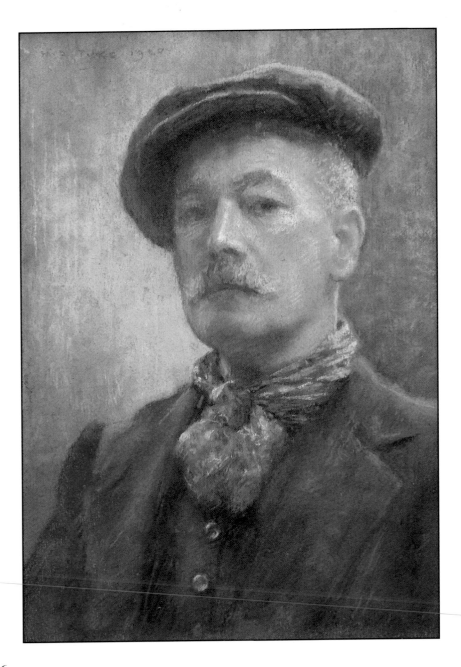

Self-portrait 1920
pastel (36 x 25)cms
Royal Institute of Cornwall, Truro.
This portrait belonged to Colin Kennedy and was presented after his death to Truro. Illustrated in Maria Tuke Sainsbury's memoir as frontispiece.

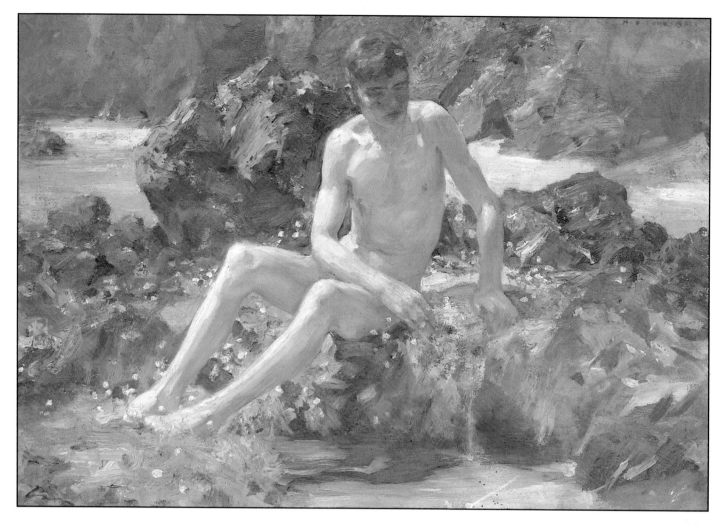

Nude on the Rocks c.1917?
oil on board (29 x 41)cms
Courtesy of Sotheby's, London.

The 1914-18 war brought major changes to Tuke's life. Artistically he was more confident, continuing to take male nudes as his main subject, encouraged by a new circle of friends and admirers. Generally his style became freer and his use of paint more experimental. The war, however, caused him great upset. While he hated the hostilities he was suspicious of pacifism. In his diary he recorded the comings and goings of ships moving in and out of the harbour, fascinated yet fearful of the news they might bring. He was particularly concerned with the welfare and safety of the young men who had posed for him, and eagerly sought news of them. When they did return they told him of their experiences of the war, sometimes posing for one of his few sculptures 'The Watcher', modelled in wax and later cast in bronze, a plaster version of 'The Watcher' was shown at the

Royal Academy in 1916. The main models were Harry Giles and his loyal workshop assistant Charlie Mitchell, who had helped care for him after a serious and near deadly attack of erysipelas in 1916. 'The Watcher', a single youthful naked figure leaning on a rock is alert yet relaxed, inspired perhaps by Tuke's own experience of the war.

In the period after the war Tuke's life entered a new phase. His mother died in 1917 (his father had died in 1895) and he inherited her home Lyndon Lodge, Hanwell. Rather than sell it, he decided to retain a studio there and let the house to a group of his younger friends. Most had served in the war and included two of his patrons Leonard Duke and Jack Hone (16). Both were homosexual and through them he was introduced to Colin W.Kennedy (c1900-1962) then an architectural student. A close friendship was formed and Kennedy lived with Tuke in Falmouth, where he obtained a job with Corfield, an architect and surveyor in the town. Kennedy, along with other friends and models posed for paintings. A self portrait, carried out in pastels (p.56), was given to Kennedy and remained with him until his death.

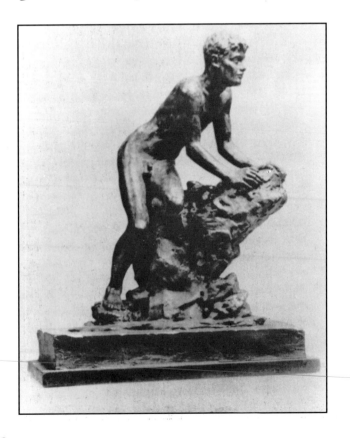

The Watcher 1916
bronze
The main models for this piece were Harry Giles and Charlie Mitchell.

opposite

Boys Bathing on Rocks c.1921
watercolour (22 x 14)cms
Courtesy of Bury Art Gallery and Museum, Lancashire.
Photograph A. J. Ashton.

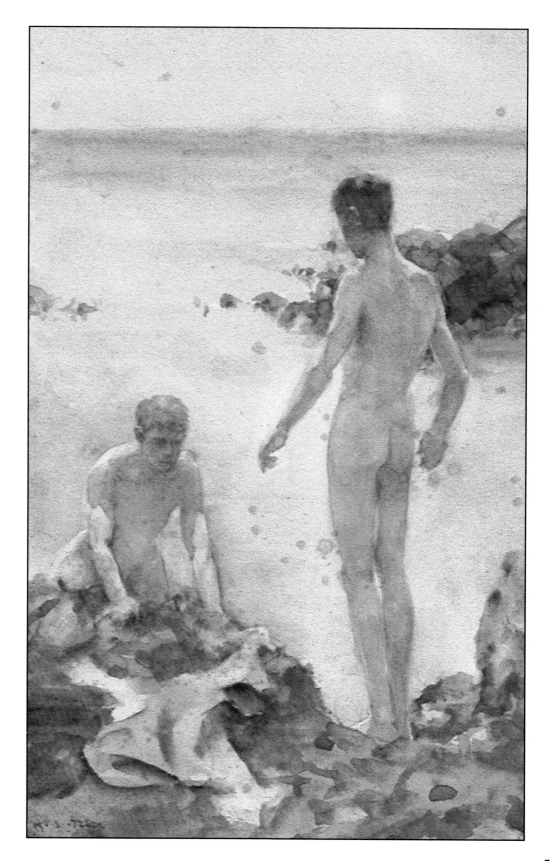

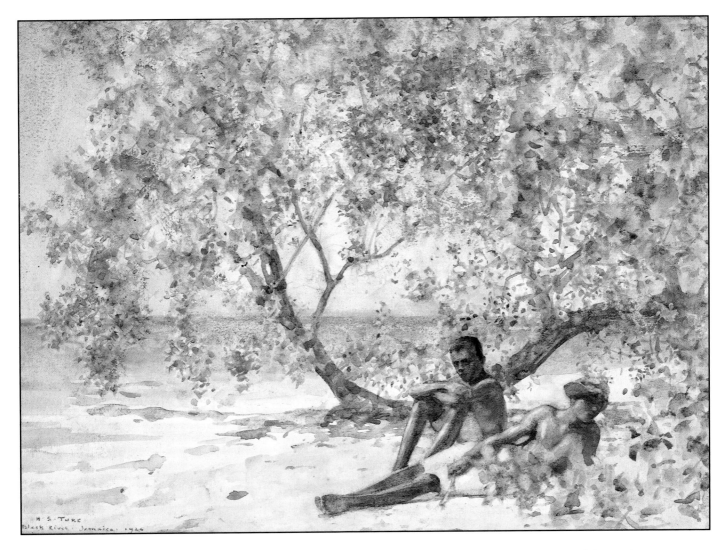

On the Fringe of the Caribbean 1924
watercolour (26 x 36)cms
Collection of Michael Holloway and David
Falconer.

Tuke's last major visit abroad was with a group of friends
to the West Indies in 1923, arriving in Kingston, Jamaica.
They toured the country before moving two months later to
Belize in British Honduras. For Tuke this was an excellent
opportunity to see and paint exotic places, and though his
fine watercolour pigments were stolen he was able to
continue painting though with less refined materials. He still
achieved excellent effects as for example 'On the Fringe of the
Caribbean' (above). 'Black Water Boatman' and 'The Man-
grove Swamp' were later exhibited at the Royal Academy,

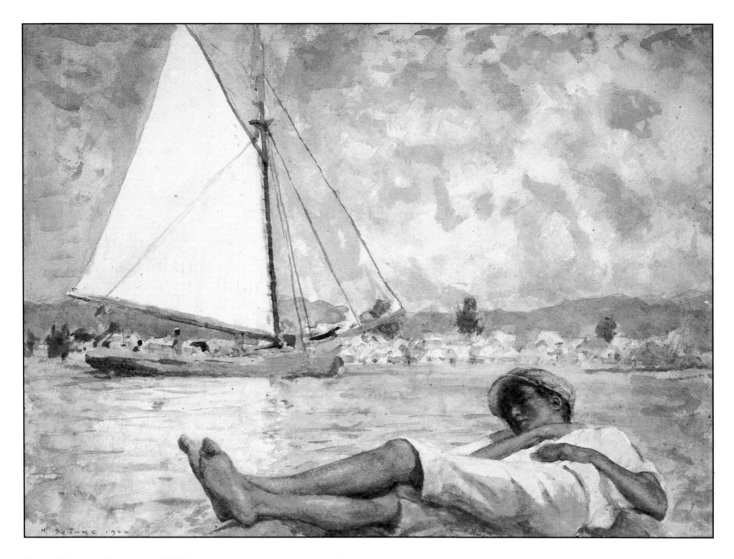

Sunny Hours in Jamaica c.1924
watercolour (16 x 36)cms
Private collection.
Illustrated opposite p.164 in 'Henry Scott
Tuke' by Maria Scott Tuke.

while 'Sunny Hours in Jamaica'(*above*)of a youth lying in the prow of a boat against a beautiful dappled sky and magnificent sailing boat, was chosen as an illustration for his biography by his sister. Unfortunately Tuke found the heat and insects made painting difficult and later in the trip he became seriously ill with dysentry. In a poor state of health he was forced to leave his companions and return to England in April. His family and friends were worried by his ill appearance and some thought that he never really regained his vigour.

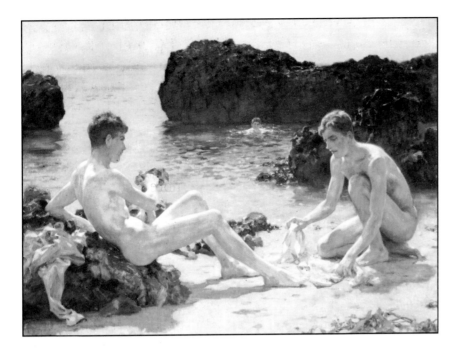

The Sun Bathers 1927
oil on canvas (91 x 122)cms
Courtesy of Sotheby's, London.
*Painted on Newporth Beach 1925-26; the
model was Charlie Mitchell (in two poses);
the head was that of Gordon Passell.*

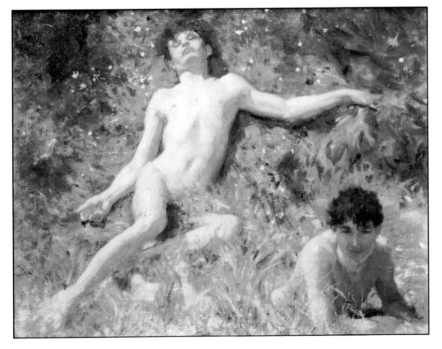

The Sunbathers c.1926
oil on canvas (49 x 59)cms
Courtesy of Sotheby's, London.

In his final years Tuke continued to paint much as before, though often plagued by poor health. His work still attracted an enthusiastic group of admirers who regularly bought his paintings. In 1925 he went on a two month tour of the Mediterranean and North Africa, spending a few days with a friend in Paris on the way. A visit to Genoa disappointed him for, as he wrote in his diary 'the old ships were no more', the sailing ships replaced by 'a dowdy-looking group of coasters'. A tour of Algiers and Tunis proved more enjoyable. A year later he was back in the Mediterranean. As well as showing his work at the Royal Academy, he continued to send watercolours to the Royal Watercolour Society, showing in 1926 alongside J.S.Sargent. One of his last major oils 'Sun Bathers' (p.62), painted on Newporth Beach, of two youths on the sand and one swimming in the water lacks none of Tuke's skill. 'Sun Bathers' was shown at the Royal Academy in 1927. Colin Kennedy posed for a portrait sketch in 1928 but Tuke was already finding it hard to paint in oils though he was still able to work on 'Aquamarine' (p.65).

A serious heart attack in 1928 left Tuke weak and ill and he needed constant care. He was unable to travel to London for the election of the President of the Royal Academy. Tuke died quietly in the early morning of March 13th, 1929. In his diary, which he kept for over forty years, his final entry reads 'All stopping in dark and grey'. Appropriately it was, in the end, an analogy with light that ushered in his death. Tuke was buried at the highest point of Falmouth cemetery within sight of his home and of his beloved sea.

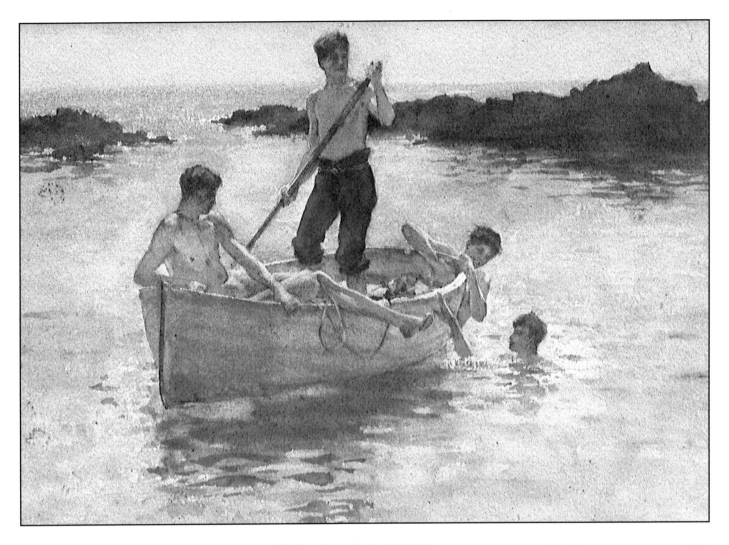

Boys Bathing from a Rowing Boat c.1921
watercolour (25 x 40)cms
Courtesy of Bury Art Gallery and
Museum, Lancashire.
Photograph A .J. Ashton.

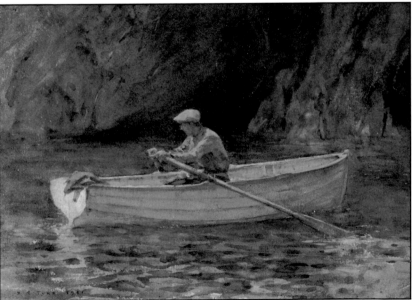

The Young Boatman 1921
watercolour (38 x 51)cms
Paisnel Gallery.
Exhibited at the Royal Watercolour Society.

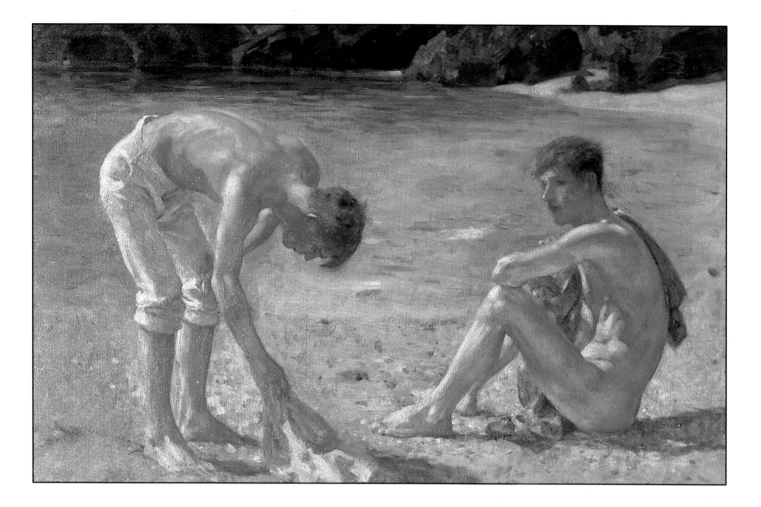

Aquamarine 1928-29
oil on canvas (66 x 97)cms
Private collection.
One of Tuke's last paintings. Probably painted in Sunny Cove.

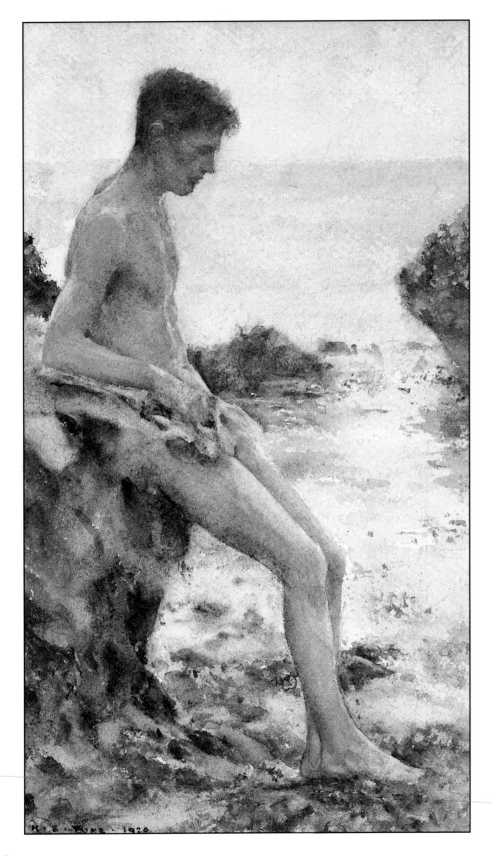

Youth on Beach 1920
watercolour (25 x 15)cms
Collection of Michael Holloway and David
Falconer.

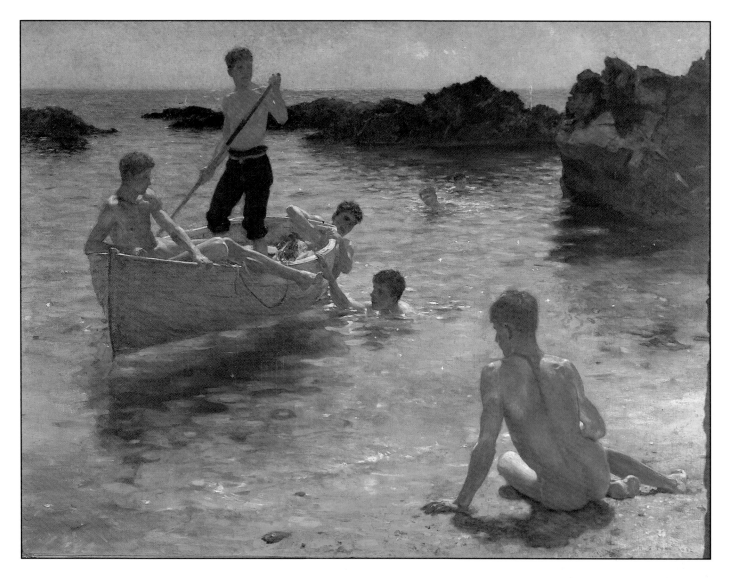

Morning Splendour 1921
oil on canvas (112 x 151)cms
Baden-Powell House, London.
Charlie Mitchell was the chief model, also
Willy Sainsbury, Leo Marshall and Georgie
Fouracre.

Notes

1 E. B. S. [E. Bonny Steyne], 'Afternoons in Studios: Henry Scott Tuke at Falmouth', *Studio* V (1895), pp90-96.

2 Maria Tuke Sainsbury, *Henry Scott Tuke*, London, 1933. A memoir written by Tuke's sister based on his letters and diaries. Quotations throughout are from this memoir unless stated otherwise.

3 Thomas Alexander Harrison (1853-1930) was born in Philadelphia; after studying in the USA he moved to Paris where he was greatly influenced by Gérome and Bastien Lepage. He painted landscape and marine pictures as well as outdoor studies of the nude: one is illustrated in Richard Muther, *The History of Modern Painting Vol.III.* He died in Paris.

4 E. B. Steyne, ibid.

5 Quoted in Caroline Fox and Francis Greenacre, *Artists of the Newlyn School*, exhibition catalogue. Newlyn Orian Galleries, 1979.

6 A full account of this fascinating group is given in Timothy d'Arch Smith, *Love in Earnest*, London, 1970.

7 See also Gleeson White, 'The Nude in Photography: with Some Studies taken in the Open Air', *Studio* I, 3 (June 1893).

8 Lord Ronald Gower (1845-1916), a sculptor, art critic and member of parliament, and a discreet homosexual. He was used as the model for Lord Henry Wotton by Oscar Wilde.

9 In 1892 Tuke went to Rome where he thought the 'Vatican sculptures are a dream of delight. I don't think much of the Apollo Belvedere or the Laocoon, but the Apoxyomenos-Athlete with Scraper – is beyond everything.' Maria Tuke Sainsbury, p101.

10 'Nobody has painted boys better than this Cornish artist since the days of Fred Walker,' noted *The Artist*, 1 May 1889. Quoted in Brian Reade, *The Sexual Heretics*, London, 1970. Frederick Walker (1840-75) was a friend and fellow student of Simeon Solomon. Walker's 'The Bathers' (1866-67) inspired the Uranian poet Stuart Young to write a poem on the beauty of youth.

11 William H. Bartlett (1858-1932) studied in Paris at l'École des Beaux Arts and with Gérome. He settled in Chelsea, and showed work at the Royal Academy from 1880. Bartlett specialised in swimmers, fishing boats and domestic interiors.

12 The *Liverpool Courier* carried a cartoon of Tuke's painting 'Summer Sea' shown in the Royal Academy Summer Exhibition 1924. One of the swimming boys has a balloon saying 'Hey! It's my turn to be in the boat, you were in it last year and the year before.' The caption below reads: 'Mr Tuke is represented, for the umpteenth year in succession, by yet another magnificently painted 'Boys Bathing' picture. Next year he'll perhaps vary his 'one in the boat and two in the water' by having one in the water and two in the boat!'

13 George Wheatley Cobb brought the Foudroyant to Falmouth in 1907 where he ran it as a training vessel until 1930. Photographs of homosexual orgies taken aboard the Foudroyant were in circulation for some years.

14 Maria Tuke Sainsbury records that Tuke saw an exhibition of Monet's work in London in 1889 of which he said, 'I like two or three very much, some of them detestable.'

15 E. B. Steyne, ibid.

16 John Alfred Hone (1895-1978) served in the Royal Flying Corps and was one of four who rented Lyndon Lodge from Tuke until 1921. He was one of Tuke's executors.

Additional References

 Klickman, Flora, 'An interview with Mr H. S. Tuke' in *The Windsor Magazine* Vol. l, Jan-June 1895.

 Price, B. D. (ed), *Tuke Reminiscences*. Falmouth: Royal Cornwall Polytechnic Society 1983. Recorded reminiscences of 24 people who knew Tuke.

 Price, B. D. (annotator), *The Registers of Henry Scott Tuke (1858-1929)*. Falmouth: Royal Cornwall Polytechnic Society. Second edition 1983.

 Price, B. D. (ed.), *The Diary of Henry Scott Tuke. 12 March 1899 – 31 December 1905. Falmouth: Royal Cornwall Polytechnic Society.*

 Henry Scott Tuke R.A., R.W.S. His Life and Work, exhibition catalogue. Falmouth Art Gallery. June 1980.

 Kate Dinn, *Coming Home to Falmouth*, exhibition catalogue: paintings and drawings by Henry Scott Tuke, R. A. Falmouth Art Gallery, June 1985.

 Gleeson White (ed), *The Master Painters of Britain*, C. Combridge, Birmingham, 1910. A fascinating survey of contemporary painters, well illustrated with a useful biographical appendix.

Many people have helped with the collection of this material: in particular I would like to thank Timothy d'Arch Smith, David Cheshire, David Falconer, Albert Galichan, Alan and Mary Hobart, Michael Holloway, David Horbury, Francis King, David Messum, Stephen and Sylvia Paisnel, Barry Prothero, Peter Rose, and Sir Anthony Tuke.

Index to Colour Plates

Index to black and white reproductions

List of photographs of Tuke